ASPECT OF
REVOLUTION
IN NIGERIA

ASPECT OF REVOLUTION IN NIGERIA

RICHARD IGIRI

AuthorHouse™ UK Ltd.
1663 Liberty Drive
Bloomington, IN 47403 USA
www.authorhouse.co.uk
Phone: 0800.197.4150

© *2014 Richard Igiri. All rights reserved.*

No part of this book may be reproduced, stored in a retrieval system, or transmitted by any means without the written permission of the author.

Published by AuthorHouse 07/09/2014

ISBN: 978-1-4969-8212-4 (sc)
ISBN: 978-1-4969-8481-4 (hc)
ISBN: 978-1-4969-8482-1 (e)

Any people depicted in stock imagery provided by Thinkstock are models, and such images are being used for illustrative purposes only. Certain stock imagery © Thinkstock.

This book is printed on acid-free paper.

Because of the dynamic nature of the Internet, any web addresses or links contained in this book may have changed since publication and may no longer be valid. The views expressed in this work are solely those of the author and do not necessarily reflect the views of the publisher, and the publisher hereby disclaims any responsibility for them.

Contents

Introduction KEY TO THE SACRED VERSES vii

- Chapter 1 THE ASPECT .. 1
- Chapter 2 CONCEPTS IN THE HOLY PROPHECY 7
- Chapter 3 DESTINY OF AFRICA 20
- Chapter 4 VOLUME ONE OVERVIEW 25
- Chapter 5 VOLUME TWO OVERVIEW 37
- Chapter 6 POETRY IN REVOLUTION 64
- Chapter 7 INDICES OF NIGERIA'S CESSATION 73

Conclusion ... 103

Appendix .. 125

Introduction
KEY TO THE SACRED VERSES

I did not wake up one morning just to decide I was going to write the Sacred Verses in *Prophecy of Democracy*. A series of spiritually elevating incidents led right up to it. It was almost as if I was "called" by God Himself – "Thou shalt write this *Holy Prophecy* unto my People!"

And so, as if I was Jonah in the belly of the whale – pushed to the wall after my every futile effort to abandon this *Divine Call* in pursuit of my own mundane interests in life – I had no choice but to heed The Call onto Greater *Service to Life*.

The word *Biafra* shows up so prominently in the *Sacred Verses*, but this is really not a book "about Biafra" as in the historical perspective of "Biafra", which would dwell upon a certain satanic history of perpetrated atrocity against the proverbial "Jews in Nigeria".

Also, I did not plan it would take an approximate 20 years (1992-2012) to "complete" the *Sacred Verses*. The originality and consistency of the vision in the work has been such that through these years of writing and re-writing, the original structure did not alter one bit. I have only experimented with titles as a way of appraising several creative perspectives of the work, all at once.

The fundamentality of the theme of these *Sacred Verses* is not *Biafra* really, but *Democracy*. This *Holy Book of the Revolution* therefore concerns itself with *Biafra* only in the intellectual and existential context of the connection between *Biafra* (*Self*-Discovery of the African Identity) and *Democracy*. The *Sacred Verses* dwell upon *Democracy* not just as a political process but as an *existential ideal* of *Self*-Discovery as in the value-system constituting the *New World Order*.

Richard Igiri

The difficulty encountered by some students in reading of the *Sacred Verses*, necessitated that I attempt to write a "Key", which helps to familiarize others with this *Poetic Fantasy*, ever before they come into actual contact with it. Thus, this *Key to the Sacred Verses* is intended to actually familiarize the student of the Revolution with this *Poetic Fantasy,* such that after reading *Aspect of Revolution in Nigeria*, he or she may wish to go further into the *Sacred Verses* with enthusiasm enjoying its divine poetry for its entertainment value if for nothing else.

The highly structured and "uncomfortable" language of the *Sacred Verses* is by deliberate design and should be appreciated as such. Why was it absolutely necessary to write the *Holy Scriptures of the Revolution* in such a self-distancing, structured, poetic, and dreamy language?

This *Poetic Fantasy* is a Long *Poem* in itself, and issues forth from a perspective of spiritually elevated consciousness. But one good advantage in the elevation of its language is that it distances the *Sacred Verses* from its critics – and especially street-prattler, blackberry-scribbler critics of *Indigenous* Nations of *New Age* Africa, as representing the existential ideal of *Self*-Discovery of the African Identity.

Upon the *New Age* mentation resident in the *Sacred Verses,* the gem of history for example designated *Biafra,* dons an African renascence symbolism: it becomes "*Self*-Discovery of the African *Identity* in Spiritual *Purity* and Cultural *Originality*" in the *Within,* being as opposed to "*European*-Discovery of the African *Character* in Ideological *Artificiality* and Cultural *Superficiality*" from *Without*.

The word-concept *Biafra* occurs in the *Sacred Verses* only in that existential and intellectual context. Ojukwu himself philosophized upon the "Biafra of the *mind*" as set-apart from the "Biafra of the *fields*". In *Summary of Volume Two,* 9.4, the *Sacred Verses of the Revolution* equally rediscovers *Biafra* in its divine status of "Democratic *Conciliationism*", being as in an aggressive evacuation from its historical non-status in "Military *Confrontationism*".

Thus the uncompromisingly structured and poetic language of the *Sacred Verses* serves the advantage of defining *Biafra* (not as a bigoted ethnicist-militarist ambition, but) as an Existential Ideal of *Self Discovery of the African Identity,* which distances this Sacred Ideal from its less-than-erudite critics.

We must remain constantly mindful of the fact that the *Old World* era has come to its obsolescence, wherein only illiteracy and savagery determined the unity and sovereignty of a "nation" as in the Nigeria experiment. The failure and opprobrium of Nigeria is a classic example of what obtains when a "nation" derives existence solely from illiteracy and terror – as an *imposition* upon its "citizens". *Democracy* otherwise is a situation in which we must *Debate* (as in the *Sacred Verses of the Revolution*) to achieve *Nationhood,* as opposed to *Dictate* the unity of a "nation" on the ill-authenticity of illiteracy and Civil *Error*; with mal-authority of sovereignty sourced from Evil *Terror* and savagery.

Therefore the *Nigerianist* who may remain inclined against emergence of *Indigenous* Nations of *New Age* Africa must face the huge challenge constituted in the *Sacred Verses,* which mandate embrace of debate and intellectualism on the sacred path of pristine *Nationhood* and *Democracy*. The pressure of *Democracy* is upon such *Nigerianists* to present to the whole world a well-articulated blueprint of *Nationhood* for *New Age* Africa (as typified in the *Sacred Verses*), than depend so heavily on Civil *Error* and *Intimidationism* to determine unity; with Evil *Terror* and *Impositionism* to define the sovereignty of a "nation"!

Chapter One
THE ASPECT

And thus considering the title *Prophecy of Democracy* – what is the prophecy of Democracy for Nigeria? Prophecy herein denotes "future". We would, if we could, peer into the proverbial crystal ball seeking a glimpse into the *future* of Democracy in Nigeria, and indeed Africa among the "Independent" Nativities of the *Former European Colonies.*

Going by what the *Sacred Verses* designates the *Sacrosanct* Democracy, what really is the future of *Democracy* in Nigeria?

According to the Sacred Verses, when *Sacrosanct* Democracy finally dawns upon *Niger Area*, it would primarily seek *Self Discovery* of the African Identity; secondarily seeking institution of *Indigenous* Nations of *New Age* Africa as upon *Self Discovery* of the African Identity. The divine logic herein thus lies in that a *Colonial Relic* like Nigeria is nothing but a (toxic) product of *European "Discovery"* of the African Character and remains vastly flawed and untenable by the spiritual and cultural precedents of the emergent *New Age* Africa.

A look at the history of the human race acquaints us with the hard fact that it takes more than brute force of arms as in *Conquest* and *Colonization* from *without*, to found a *Nation within*. Brute force of arms can (*artificially*) create a *Country* (as in *Nigeria*): but the foundation of a *Nation* costs much more than *coercion* as of *Political Capture* and *Military Torture* such as it took to concoct *Nigeria* into its maniacal Ideological *Artificiality* and morbid Cultural *Superficiality*. The true status of *Nationhood* lies existent as well as resident, only upon the existential premise of (what the *Sacred Verses* designates) *Indigenous Consensus* as in *Self* Discovery of the African Identity.

Thus in the stead of one weak *Country* barely wobbling along contradiction-ridden in the civil fraudulence of its Political *Turbulence*, as well as conflict-driven by the evil violence of its Military *Pestilence*, the vision in these *Sacred Verses of the Revolution* is such that *Sacrosanct* Democracy would institute three powerful *Indigenous Nations* in Spiritual *Vivacity* and Cultural *Vitality*, which totally resonate existential ideals of *Self Discovery* of the African Identity as of Sacrosanct *Democracy*.

The first-ever computer print-out of the First Volume of *Prophecy of Democracy* came through in 2010. I gave out some copies to intellectuals whom I adjudge distinguished members of my "target readership". The chief complaint has been about the Sacred Verses being very "uncomfortable" and "difficult' to read. While some were patient enough to painstakingly wade through this *Holy Book of the Revolution* verse by verse and have fun at it, others were not so patient and poetically inclined. Everyone however, seemed to have quite an interest in the *Holy Book* in a general sort of way.

Thus while many did nothing but complain, a certain gentleman from Enugu was having so much *fun* reading the *Sacred Verses!* He calls himself "a voracious reader", and is simply *fascinated* by the art in the Sacred Verses, speaking of these in glowing terms! This proves that the *Sacred Verses of the Revolution* is not totally impenetrable and unreadable for *everyone* as some would have us believe.

According to this respondent, the *Sacred Verses* stretches his mental and intellectual virtues to their limit. That is a good point because the Sacred Verses on *purpose* set out to *task* the Revolutionary to *find* Nationhood *within* himself first! According to the Sacred Verses, *Nationhood* is first *cultivated within* (in Spiritual *Subjectivity)*, which empowers the Revolutionary for Nationhood to be *developed without* (in Physical *Objectivity)*.

For the interest of those who though having a profound interest in the *Sacred Verses*, may be put off by its awing technicalness, I came under pressure to do a quick commentary, which would serve as a *"key"* of some kind, to unlock the *Holy Book of the Revolution*,

making the essence of it accessible at a glance. This *Key* would not serve to displace or replace the *Poetic Fantasy* itself, but would only serve as synopsis of a kind, which helps the student get in sync with it, without going through the daunting rigor of having to actually read it.

For those who may be determined to read the *Sacred Verses of the Revolution*, this *Key* I would suppose, goes a long way in wiping out the possibility of being put off by the high-sounding "technicalness" and poetic elevation of its language. I have actually *shelved* the Sacred Verses *Prophecy of Democracy* as a *textbook* of sorts! Its "difficult" and "unfriendly" nature have categorized it as a *Textbook of the Revolution* – put aside only for reference purposes in the intellectualism of the *Revolution!*

I devised that this *Key* to the *Sacred Verses* would be so reader-friendly that the Revolutionary could comfortably browse through it while on a bus homeward from work, or conveniently as a matter of fact, while waiting to be served launch at a restaurant. While the high technical subtlety of *Prophecy of Democracy* continues to be resident in the *Sacred Verses* itself for the Revolutionary who contains the need or curiosity to pry beyond summary and commentary, this *Key* presents the theme in a quickly accessible form.

In order to make this *Key* to the *Sacred Verses* totally reader-friendly, let us explore the context of the word "aspect" in *Aspect of Revolution in Nigeria*. Webster's Ninth New Collegiate Dictionary (the official Dictionary of the *Sacred Verses*) uses these phrases among others, in defining "aspect" – *"a particular appearance"*... *"countenance"*..."mien".

Hence "aspect" in the title of this *Key* to the *Sacred Verses* is to be taken in the context of the *face* that *Revolution* would wear in Nigeria. This considers "how" the divine concept of *Revolution* applies in the existential tragedy known as *Nigeria*.

What would Revolution *look like* when it finally dawns upon Nigeria? What *face* would it be wearing? In this context, we could even call this Key the *Face of Revolution in Nigeria*.

We've heard about, as well as seen Revolution in other parts of the world. Let's not even bother so much with aspects of Revolution in the remote past, such as the French Revolution, the Renaissance, *et cetera*. Let's be concerned with the more recent aspects of *Revolution* such as *Fall of the Berlin Wall, Break-Up of Communist USSR, Abolition of Apartheid South Africa*. These world incidents would seem to be so commonplace to us, since we witnessed them and are part of their making, than having read them up in our history books. But how often do we pause to consider that these aspects of Revolution which we are mortal witnesses of came upon us imbued with spiritual significance and cultural relevance in the development of the *Human Race* being of no status less than those ethereal Revolutions of the history books?

Do we ever pause to consider *Black Man in the White House* as a classic *Revolution* of spiritual significance and cultural relevance totally comparable to that of those seeming ethereal Revolutions of the history books that we would wish we were alive to be witnesses of? Or do we overlook its true spiritual significance and cultural relevance in the *New World Order* of *Sacrosanct* Democracy, just because this great *Revolution* took place right under our very own noses?

So, by what *aspect* does Revolution dawn upon Nigeria?

The *Sacred Verses* attempts to capture the *aspect* of Revolution in Nigeria.

Let us re-visit that contrary to face-values, *Prophecy of Democracy* (even when alternatively called *Divine Psychology of the Revolution of Biafra*) is really not a book "about Biafra". This *Poetic Fantasy of Revolution* is of spiritual flexibility such that the sacred word *Biafra* could easily be substituted with *Oduduwa* or *Arewa* as may excite the imagination of the Revolutionary.

The flexibility of the book is such that it could very conveniently don any of the imaginative titles the Revolutionary could come up with. In the innovative, creative and imaginative appraisal of the book, the *Divine Psychology of the Revolution*, the *Poetic Fantasy of the Revolution*, the *Sacred Verses of the Revolution*, the *Holy Scriptures of the Revolution*, *Textbook of the Revolution, et cetera*, all constitute innovative designations as applicable in reference to *Prophecy of Democracy*.

Let us conclude on *The Aspect* by considering that any *Country* laying claim to the existential status of *Nationhood* must be capable of *self-transcendence*. Just as the status of pristine *Nationhood* is one of *self-invention*, the *continuing validation* of Nationhood as in its validity-relevance against shifting world trends necessitates self-*re*invention.

Black Man in the White House, which would have seemed a laughable – even "sacrilegious" – impossibility only a few days ago, came upon us in Americanism as a classic of self-invention and self-*re*invention – self-transcendence in *Nationhood*. It was the transcendental status of *Nationhood* in America – obeying the law of self-reinvention for self-transcendence on the path of self-immortalization – which made this great *Revolution* possible. A *Nation* which successfully breaks the barriers and scales restrictions of its negative cultural stereotypes loses nothing and very rarely derails from its path of greatness. It actually gains the whole world in this way by accession to a loftier status of its greatness as a *Nation*.

By its spiritual significance and cultural relevance, *Black Man in the White House* – than diminish her stature in any way – actually raises America to an ever greater height of its spiritual greatness and cultural prosperity. This one *Revolution* paves the way for America's attainment of levels of greatness once unthinkable and impossible. How is this so? Simple: A certain "bar" has been surmounted in its self-*re*inventionism, constituting a Nation's *self-transcendence* against the limitations of an out-going World Era. The divine status of Self-*re*invention thus gears a *Nation* to explore the spiritual latencies

and exploit the cultural potencies of the in-coming World Era onto greater greatness.

As against the Nigeria experience, the lesson to be learned from this *Revolution* in America is that a *Nation,* who already has greatness as a ground reality, must continue to *dismantle* old stereotypes and *create* new value-systems for its greatness to continue to prosper onto greater heights. No status of greatness is absolute in itself. This goes for *Nations* that are generally held as having already achieved greatness, such as the United States of America. But what should be said of *Countries* – like Nigeria – still wallowed in corruption-ridden non-identity and mediocrity, swallowed thus in wickedness-driven non-directionality and futility?

The Truth is that no sacrifice in the *Regenerative* direction is too much to be made in the Nigeria experiment onto true greatness and pristine *Nationhood.* According to the *Sacred Verses of the Revolution,* Nigeria is only a *Seed* of Greatness, which must be peaceably *sown* into the bowels of Mother Earth for it to *germinate* (as in creatively and constructively *break up*), without which the greatness latent in that *Seed* will only diminish, atrophy, perish (Nigeria is currently and sustainedly running that satanic trajectory of its celebrated *Degenerativism*).

If we genuinely sought *Revolution* in Nigeria to unleash this God-given latent greatness, which would equal Revolutions in other times and climes (*Black Man in the White House* for example), what would such a Revolution look like? What *aspect* would it take? Might it don the primary aspect of a spiritual and intellectual *Awakening* soliciting *Self Discovery of the African Identity* in its Spiritual *Purity* and Cultural *Originality*, as opposed to elicited European Discovery of the African Character in Ideological *Artificiality* and Cultural *Superficiality*?

Chapter Two
CONCEPTS IN THE HOLY PROPHECY

The *Sacred Verses of the Revolution* employs contrast, rhymes, as well as "invented" terminology to deliver outlandish abstractions onto concrete grasp. Some sections of the Sacred Verses occur in prose, others in semi-prose, while others are given in pure poetry. The *Holy Prophecy* thus is generally given in a highly structured and elevated, rhythmic and poetic language.

This *Holy Prophecy* is given in two Volumes. Volume One and Volume Two relate as opposites. Thus while Volume One addresses the theme *Cessation of Iniquity*, Volume Two addresses the theme *Foundation of Dignity*. *Cessation* rhymes with *Foundation*, while *Iniquity* rhymes with *Dignity*, but by content and context, these rhyme-pairs are antitheses.

A builder who breaks ground, usually clears up the entire site of all old, ailing structures. He comes up with a plan *better* than the planlessness of the old, obsolescent structures. He proceeds to foundation and on to construction of a *new* structure. It is in this wise that Volume One of the Holy Prophecy occupies with *Cessation of the Iniquity of Man* in the African sphere of existence, while Volume Two preoccupies with *Foundation of the Dignity of Man* in the African theater of experience.

The First Volume of the Holy Prophecy addresses a situation in which *Supreme Being*, by His Own Hand, brings *Iniquity* to an end. *Iniquity* thus comes to *Cessation* in the African theater of experience. In such a transcendental scenario of Divine Intervention, the Iniquity of Man

ceases to exist – by the Supreme Being's Own Divine Hand. This is *Revolution*.

The Second Volume addresses a transcendental scenario in which *Supreme Being* brings *Dignity* to inception, to *Foundation*. This would mean that the Dignity of Man *begins to exist*, totally operative in the African sphere of existence. This is *Evolution*.

Iniquity rhymes with *Dignity*, yet they are diametrical opposites. *Cessation* equally rhymes with *Foundation*, with the same sharp-contrast essence and value.

Throughout the *Poetic Fantasy*, we do also have rhyme-contrast schemes such as *Transcendental* and *Satanical*. These two words form a perfect rhyme pair, yet strike such sharp contrast by relative essence and value. That which is *Satanical* is not *Transcendental*, while that being Transcendental can never become Satanical.

The *Holy Book of the Revolution* also features, amid a myriad of other rhyme-pairs, *Civil-Evil, Terror-Error, Captivity-Liberty, Individualism-Nigerianism, Nationhood-Niggahood, et cetera*. The student of the *Holy Prophecy* thus must make extra effort to pause at this structuring as to extract content, than simply vague-over this deliberately intricate design as mere jargon.

The *Holy Prophecy* dwells on its own custom-generated terminology in delivering apprehension of its spiritual content, as well as comprehension of its cultural context. The uniqueness of the existential tragedy known as *Nigeria* – which the Holy Prophecy attempts to heal – necessitates inventiveness for analyzing its demonical virulence into divine restoration as a peculiar-tragic trend of human existence and experience.

In verses 1 and 3b of Volume 1.*Preface.d* titled *Language of the Revolution*, the Holy Scriptures of the Revolution puts it thus:

Aspect of Revolution in Nigeria

> 1 The Language of the Revolution features a game of word-jugglery. This goes to the advantage of the student of the Revolution. The obvious peculiarities of the African IdentityExistence make patterns of the African CharacterExperience that uniquely, only African. By this little game of ours therefore, we invent words for depiction of these concepts and situations onto such vast lucidity as grants the student of the Revolution apprehension of their spiritual content, as well as comprehension of their cultural context, almost experientially.
>
> 3b In the Language of the Revolution thus, the classical African knack to improvise for survival, revives. Thus going by the philosophy in the Language of the Revolution, the African Identity-&-Character must at last *invent!* He cannot continue to be invented and "discovered" by intelligences of the *Negative* kind, and by forces of the *Degenerative* character, but all from without the essences and exigencies of African Survivalism. This fact necessitates going it by this totally *Native – imaginative* – easy way of inventiveness in our study of the Revolution.

The foregoing introduction to the diction of the *Poetic Fantasy* comes in handy in preparing the student of the Revolution mentally to appreciate its eccentricity and imbibe its literary culture, while basking in the transcendental humor thereof.

The *Sacred Verses* owes much of its forcefulness to its vast array of custom-words, which serve to penetrate the hard crust of the eccentricity of the African existence and experience in analyzing its conflicts and crises into resolution. The eccentricity of the language thus facilitates the process of unraveling the content of the conflicts of the African IdentityExistence for *Cultivation*, as well as the context of the crises of the African CharacterExperience, for *Development*.

The student of the *Holy Scriptures of the Revolution* should spare to write off these words as "geek" and "big" words. They would not seem so impenetrable once the student applies patience to unravel their nature and origin, which is what this *Key* hopes to assist with. The sincere student should not become disinterested on account of

these custom-words – which are in fact key-words in the Sacred Verses. Regarding terminologies and the concepts depicted thus, once put in proper perspective as in this *Key*, the *Holy Prophecy* would no longer seem so "uncomfortable", dense and impenetrable.

The *Holy Prophecy* employs a certain controversial word, whose context and content in these Sacred Verses the student must be totally conversant with, in order to part-take of the humor and enlightenment thereof.

In verse 4 of Volume 1.*Preface.d* the Sacred Verses begins introduction of the controversial word thus:

> 4 This humor-geared word, equally, a malice-charged word, was a coinage of the early racist-white slave-driver philosophers and slave-lord sermonizers, for derogation of the black man. This controversial word is only a corruption of the word *negro*. Coined for derogation of the black man, it actually was more derogative to the white user. But, we must muse, if the *Degenerate* white man employed this controversial word for denigration and derogation of the black man, in what context does the *Regenerate* black man employ an artful inflection of this word (as in the *Language of the Revolution*)?
>
> 5 The *Regenerative* black man chooses employment of an inflection of this word, not in any context of self-derogation. Employment of this imaginative word (in the Language of the Revolution) serves not signification of self-hatred, nor does apply to imply self-derogation. ... The *Regenerative* black man thus has only employed an inflection of this controversial word for qualification of *Self-criticism*.
>
> 5b In Self-criticism lies the spiritual rearing for Self-improvement as well as derives the intellectual gearing thus, for *Self-mastery*. Therefore the word *nigga*, being as in the *Language of the Revolution*, applies most strictly in the context of *Self-criticism* only, being as for *Self-improvement*, onto *Self-mastery*.

Aspect of Revolution in Nigeria

> 6 In the context of *Self-criticism* thus, *nigga* in the Sacred Verses designates the *negative side of the black man*. This totally negates every possibility that the black man were in himself, an existential Negativism. ... This word however does indicate that the black man *has* a "ghost-picture", a "shadow-effect", as embodied in the *niggaman*.
>
> 6b The *Sacred Verses* thus brings to focus the black man's "ghost-picture" ... in the context of Self-criticism, for Self-improvement, and ultimately onto the impeccable and inviolable status of *Self-mastery*.

We may consider the following concepts in the Holy Prophecy in some detail thus –

<p align="center">
Unism – Dualism

Transcendental – Satanical

SelfIdeationism – Intimidationism

SelfCreationism – Impositionism

Existential <i>Ideal</i> – Experiential <i>Ordeal</i>

Nationhood <i>Craft</i> – Niggahood <i>Draft</i>

Kinte – Toby

Individualism – Nigerianism

Nationhood <i>Science</i> – Niggahood <i>Nescience</i>

Volition – Violation

Perpetuated – Perpetrated

Inhibit – Inhabit

<i>Dignity – Iniquity</i>
</p>

Unism denotes the existential Win-*Win* situation, which is the Desirable existence. *Dualism* on the other hand connotes the existential Win-*Lose* situation. The Win-Lose situation is the Undesirable, zero-sum experience.

The *Transcendental* is simply that value of existence which has a halo of completion and perfection in its *Liberty,* such that transcends Identity to all negativity in existence. The *Satanical* is the direct

opposite, which keeps Character tied in its *Captivity* to every imaginable negativism of experience.

The *Transcendental* is that pattern of existence which has a halo of accomplishment and perfection, sanctity and beauty; while the *Satanical* is that pattern of experience which has an aura of detraction and inconclusivity, affliction and corruption, artificiality and superficiality – *negativity and futility*.

SelfIdeation is a pivotal key-word in the Holy Prophecy, which consists of the words *Self* and *Ideate*. This word depicts an existential scenario in which Identity is empowered in *Liberty* to *Ideate* its very own *Self*.

SelfCreation consists of the words *Self* and *Creation*. This word depicts an existential scenario in which Character is empowered in *Liberty* to *Create* its very own *Self*.

An existential scenario in which Identity has *Liberty* to *Ideate* the *context of existence* by its own *Self*, is Desirable. An existential scenario in which Character has *Liberty* to *Create* the *content of experience* by its own *Self*, is equally Desirable.

Right though the Sacred Verses, we see the expression *SelfIdeation-&-SelfCreation, SelfIdeationism-&-SelfCreationism,* denoting the existential context of *Self* Portrait as in Sacrosanct *Democracy*.

In the Holy Prophecy, the polar opposite of this concept is *Intimidationism-&-Impositionism*. The words "Intimidationism" and "Impositionism" are plain words right out of the dictionary. In the Poetic Fantasy, they depict an experiential scenario in which Identity and Character are stripped of *Liberty* to *SelfIdeate* and *SelfCreate*, by which the existence of Identity is cast in the context of *Intimidationism*, while the experience of Character is by *Impositionism*.

Existential*Ideal* and Experiential*Ordeal* are key concepts in the *Holy Prophecy*. These are standard and conventional words from the

dictionary, which apply in the Poetic Fantasy by their conventional grammatical values.

In the Sacred Verses, *Nationhood* is an existential scenario in which Identity has achieved *Self* Discovery. This status of existence is in the Desirable, hence in *Cultivationism*. On the polar opposite side lies the experiential non-status of *Niggahood* (being as an expression of the *negative side of the black man*). This is of course a non-status of experience in which Character is "discovered" by forces *alien* to, and caprices *outside* of, the *Self*. Indeed the experiential non-status of *Niggahood* is such that Character is totally devoid of a proper *Self* – except as brutally *imposed* upon it from without. This non-status of experience is of course in the Undesirable, hence in *Underdevelopmentalism*.

The word "Craft" in Nationhood*Craft* denotes a situation in which Identity painstakingly *crafts* a self-portrait of existence, as a product of the *Self*. But the word "Draft" in Niggahood*Draft* connotes a situation in which Character is only "drafted" – that is by *coercion* and under *compulsion* – to become something that it is not, in its (absent) *Self*.

Also, in the terminologies Nationhood*Science* and Niggahood*Nescience*, *Science* denotes a status of Identity-Existence in which there is *Light* and *Knowledge*, whereas *Nescience* connotes a non-status of Character-Experience in which only *Darkness* and *Ignorance* reign supreme.

The Holy Prophecy also features these concept-terminologies: *Pseudotopia, Niggatopia,* and *Dystopia*. These words have a common suffix, *-topia*. This suffix *-topia* relates to Greek *topos*, suggesting *place* or *country* – and perhaps even "nation". Since *pseudo* designates *falsehood*, Pseudo-topia means *False Nation*, or *Place of Falsehood*. *Niggatopia* thus means the "nation" of the *Negative Side of the Black Man!*

Dys means a pathological condition. Prefixed to the suffix *-topia,* this becomes *Dystopia,* which would simply mean a *Diseased Country* or *Place* – a *Pathological* Nationhood!

The Holy Prophecy borrows *Kinte* and *Toby* from Alex Haley's book *Roots.* In that book *Roots, Kunta Kinte* represented the "conscious" African Identity, who knew who he really was as well as remained aware of his origin. *Toby* on the other hand was the slave name-tag brutally etched upon him by his White Master. The White Master's aim was to obliterate every "conscious" self-knowledge and self-memory of his slave's origin as resident in his ancestral name *Kunta Kinte.* Through means of brutality and savagery, the White Master pummeled *Kunta Kinte* into submission to the status of a submissive slave name-tagged *Toby.*

In the *Holy Prophecy*, this symbolism (*Kinte* and *Toby*) applies in depiction of the glaring and blaring difference between *Nationhood* and *Niggahood,* between *Civil Liberty* and *Evil Captivity.* This would apply for example in the violent divergence and estrangement between *Self* Discovery of the African Identity in *Biafra,* and *European* Discovery of the African Character into *Nigeria.*

The Holy Prophecy came up with a concept to draw a sharp contrast with *Nigerianism.* This was with a view to analyzing *Nigerianism* as a pathology of *Niggahood* in the African experience, which deviates radically from the mean of any semblance of *Nationhood.*

In the Sacred Verses thus, *Individualism* is designation of the *Elite* Psychology (the *Awakened* Mind), which divinely favors *Cultivation* of the African Existence into *Nationhood. Nigerianism* on the other hand is the *Mass* Psychology (the *"Crowd* Mentality"), which demonically harbors *Underdevelopment* of the African Experience into *Niggahood.*

We might add that *Cultivation*-of-Identity and *Development*-of-Character are not supported in the satanic ambit of the *Crowd* Mentality, the demon-vice of *Nigerianism.* Identity *Cultivation* and Character *Development* into *Nationhood* thus lie in the domain of

Aspect of Revolution in Nigeria

the *Elite* Psychology, which obtain alone *beyond* Nigerianism and *without* Nigeria.

The word *nonessence (*pairing up with *obsolescence*) consists of *non* and *essence*, which simply means "*no* essence" – the *negation of essence*. This one word in the Sacred Verses therefore is by no means, neither after any fashion, a typographical error! The spelling and grammar feature of MS Word still has a problem with it and remains very uncomfortable with this one word!

Throughout the Sacred Verses, rhyme pairs remain totally occurrent, and the student of the Revolution should take extra precaution to read in between the lines wherever words appear to be similar. They are carefully and adroitly sculpted perfect rhyme schemes and by no means typographical errors as some would be tempted to call them.

Take these words for example – *volition* and *violation*, *perpetrated* and *perpetuated*, *inhibit* and *inhabit*, *Inequity* and *Iniquity, et cetera*. Spiritual content is extracted from the Poetic Fantasy only when the student of the Revolution takes care not to dismiss its deliberate, creative eccentricity as technical jargon, only to miss out on all the fun.

Consider also the humor-charged word *niggapetrodollar*. It would seem dizzying at first, but "removing brackets" to begin with, it breaks down into its component parts – *nigga, petrol* and *dollar*. We already know that *nigga* in the Sacred Verses designates the *negative side* of the black man, and we also know just what are *petrol* and our good friend, *dollar*.

Petrodollar in itself is not an evil. But when it falls into the wrong hands – the hands of the *negative side of the black man* – it is squandered in the nigga-prodigality of Feudal Harlotry and *Sin*, as well as of Genocidal Sorcery and *Savagery*. For this lone evil nigga-commodity to be the basis of the existence of a "nation" as in Nigeria is indeed pathetic and a definite "resource curse".

On concepts in the Holy Prophecy finally, we may briefly consider the key-words *Nigerianism* and *Nigerianist*. What is *Nigerianism*, and who is the *Nigerianist?*

Nigerianism is a *Niggahood Psychopathy* that puts *Darkness* for *Light*, and subordinates *Truth* to *Falsehood*. This is the satanic penchant to seek the abysm of *Niggahood* into the exalted place of *Nationhood!* Nigerianism thus is a nigga-ideology which holds *External* Natural Resource such as *Oil* as the height of Nationhood, while holds in disdain (the serious *hard work* required to access) *Internal* Spiritual Resource such as the milk of *Humanity* as the true source and veritable foundation of Nationhood. In this pattern of the Niggahood psychosis thus lies the belief that *Slavery* and *Colonialism* can bequeath the loftiest status of *Nationhood* to Africa. This "religion" thus generally afflicts the *Nigerianist* with a nigga-psychopathy of *fraudulence* and *violence*, of *pillage* and *spoilage*, of *harlotry* and *sorcery*. After all "God" (the Colonial Master) "discovered" Nigeria upon these satanic vices.

According to the Holy Prophecy, in its satanical virulence *Nigerianism* creates a topsy-turvy-dom of *Perversity* and *Adversity, Turbulence* and *Pestilence, Intimidationism* and *Impositionism, Artificiality* and *Superficiality, Fraudulence* and *Violence, Pillage* and *Spoilage*. By its demonical violence thus this Existential Pathology is one in which *Captivity* defines *Liberty, Iniquity* cowers *Dignity, Reaction* contains *Revolution, Vice* vanquishes *Virtue, Thief* buys *Chief, Mediocrity* rules *Genius, Mutiny* makes *Unity, Savagery* seals *Sovereignty* – while Satan *lords* Christ!

The *Nigerianist* is the initiated disciple of *Nigerianism*. Little wonder, in Volume 1.2.5.15c, the Sacred Verses of the Revolution designates the *Nigerianist* "A Demon-worshipper of satanical sorts after the *Order of Nigerianism*". This evil character sees himself as the smart successor to the *Colonial* Master, demonically vested with "sovereign" authority to *dictate* Unity and *pontificate* Sovereignty to Nigerians, imputing it to them what they can be and what they must never aspire to be. He metes out censure or punishment as appropriate, to those who dare to nurse any "unpatriotic" ambition

of a revolutionary escape from the Bondage of Nigeria. He is brutally indoctrinated to live a *Lie* as the only Truth he can ever know – the *Lie of Nigeria*. Thus he cannot but must be a peddler of "sovereign" frauds in order to exist.

Malcolm X's famed speech of November 10, 1963 titled *Message to the Grass Roots*, identified two kinds of "negroes" during Slavery. These were the "*House* Negro" and the "*Field* Negro". While these definitions do not apply herein by the exact same value as Malcolm X contrived in his own "violent" and racist world view, we permit ourselves to borrow these and modify them in our study of this elusive demoniac identified in the Sacred Verses of the Revolution as the *Nigerianist*.

This character – the House Negro – usually lived with the White Master, wearing his old clothes, eating his (left-over) food and sleeping in a comfortable room (in the Slaves' quarters) in the Master's home. To this character there is nothing wrong with being a Slave. Slavery is very comfortable, and he wonders and just cannot understand why his African relatives are fighting the White Master to gain freedom. Freedom from what, the House Negro would wonder. Has not the White Master provided everything – free of charge?

These words from Malcolm X's *Message to the Grassroots* as well profile the *Nigerianist:*

> And if you came to the house Negro and said, "Let's run away, let's escape, let's separate," the house Negro would look at you and say, "Man, you crazy. What you mean, separate? Where is there a better house than this? Where can I wear better clothes than this? Where can I eat better food than this?"

The *Field Negro* is intelligent and sees the real need to "escape" and "separate" from the status of a Slave. But the *House Negro* dulled by greed and idiocy sees nothing wrong with the burden of non-identity in *Slavery*. He is so comfortable in the food, clothing and housing of Slavery (*Nigeria*).

In the struggle against *Nigerianism* thus – a *satanically virulent pathology* of the African existence and experience – a *version* of the "House Negro" wallows totally discernible: the *Nigerianist!* He flies high in international superstardom, heavily leaned upon the existential misfortune of "discovered" and subdued "Nigerians". He sees nothing wrong; neither ever can see anything the matter with the *Abysm of Niggahood* in Nigeria. By the nigga-psychopathy of his demonic religion, Nigeria is the *Apogee of Nationhood!* Can anyone blame this *House Negro* – the *Nigerianist* – if he is quarreled against those who believe that *Nationhood* neither exists in Niger Area, nor is pristine *Nationhood* compatible with *Nigeria*; nor yet is *Nationhood* ever possible through *Nigerianism?*

While leaders of *Real* Nations are *Possibility* Thinkers, the *Nigerianist* is an Impossibility *Prattler.* How often do we have to contend with visionless cheap-talk of the Nigerianist such as: "Nigeria *can never* be split"? Leaders and citizens of Real Nations *Debate*: "We *can*", but all the *Nigerianist* ever does is *Dictate:* "We *cannot*", "We must *not!*"

His thought, word and deed in Nigeria are all For *Evil*, and this cripples his mentation with the rigid presupposition that the break-up of Nigeria must be For *Evil* and "can never" be For *Good*. This Satan-restrained mentation and destructive-mindset of the *Nigerianist* explains why he has failed so woefully to *create, build* or *develop* anything in the semblance of a *Nation*, except his *Blunderism and Plunderism* for a "nonnegotiable" Unity, as well as *Shootership and Lootership* for an indissoluble Sovereignty.

Great leaders of *Real* Nations with the "We-*can*" possibility-mindset could have completed a Space Station with the same resources he has only squandered over these decades of the "indissolubility" of Nigeria's *Inequity-Iniquity, Blunderism-Plunderism, Shootership-Lootership,* and *Pillage-Spoilage!*

His *Impossibility Complexes,* psychological derangement and restraint-mindset disorient as well as disable him for cultivation of the vision that the *peaceable and constructive* breakup of Nigeria can be For *Good* – to raise the Nativities onto a loftier spiritual status

of existence, as well as a higher cultural stature of experience in *Real* Nations beyond *Feudal* Conquest and *Genocidal* Colonization. Handicapped to see such *Higher Possibilities* of Life, *Intimidationist*-Blunderism and *Impositionist*-Plunderism remain his highest definitions of *Nationhood*. Thus his Comfort Zone of *Pillage* and *Spoilage, Blunderism* and *Plunderism, Shootership* and *Lootership* – must never be tampered with!

What a pathetic and satanic *nigga-politocrat* the *Nigerianist* actually is!

A fair rendition of the alarming mental corruption and obnoxious nigga-psychopathy of the *Nigerianist* would run something like this: "I *cannot* develop, therefore you *must not!* I *will not* enter Heaven, so how *dare* you try! Don't even think about it! If anyone could enter Heaven, it *should* be me – *not* you! But I do not need Heaven: *Nigeria* is perfectly Heavenly enough for me, thank you!"

Chapter Three
DESTINY OF AFRICA

Destiny of Africa is a *New Age* Mentation of the African Identity, which constitutes its liberation from the *Colonial* Mentality of the "discovered" African Character. The *New Age* Psychology thus is one *Self* Discovery of the African Identity in its Spiritual *Purity*, as well as of the African Character in its Cultural *Originality*. This lies as opposed to the *Colonial Mentality* of European "Discovery" of the African Character in Ideological *Artificiality* and Cultural *Superficiality*.

Destiny of Africa is a thought-focus of *New Age* Africa suggesting an existential scenario in which the destiny of Africa becomes *manifest*. Is it possible for the destiny of Africa to become manifest in an experiential scenario in which the African Character is "discovered" from outside of Africa?

Destiny of Africa thus suggests manifestation of the destiny of Africa in the existential context of *Self Discovery of the African Identity*. As opposed to European "discovery" of the African Character in the experiential continuum of *Slavery, Colonialism* and *Nigerianism*, this mental gearing inclines that the destiny of Africa can only be manifest in an existential context of *Self Discovery of the African Identity*.

Wielding the acronym DOA and internet-situated at www.destinyofafrica.org, *Destiny of Africa* is a mental culture in the African Identity of the *New Age* motivated in hard pursuit of that divine objective. DOA is not a social gathering or a political association as in the context of *Nigerianism*. It is rather a virtual culture of the African Identity of the *New Age* who not only must survive but must thrive in the spiritual and cultural precedents of the said *New Age*.

By the folk philosophy resident in *Destiny of Africa* as authored in hard pursuit of the divine objective of *Self Discovery of the African Identity*, Nigeria is a pathological *relic* of the *Colonial* Era of World History. This divine psychology of *New Age* Africa inclines that Nigeria has been, and remains nothing but a Dead Carcass of the *Colonial* Civilization. In DOA folk philosophy thus, Nigeria is a political opprobrium of the *New World Order*, which amounts to nothing but a huge (spiritual, ideological, social and economical) impediment to *Cultivation* of the African Identity Existence and *Development* of the African Character Experience, being as onto the existential status of *Nationhood*.

As "Nigerians" therefore, bewildered Africans will toil in vain to fit this *Old* Wine of Satanical *Niggahood* into the *New* Wineskin of Transcendental *Nationhood!*

The *New Age* Mentation as fetched in hard pursuit of the divine objective of *Self Discovery of the African Identity* upon spiritual and cultural precedents of the said *New Age*, inclines that in the stead of one weak, *agglomerated*, inept and inapt *Country*, the nascent African Identity Existence will be blessed with three powerful, *conglomerated*, beautiful and articulate *Nations*. These great *Indigenous* Nations of *New Age* Africa (in alphabetical order) would be the Republic of *Arewa*, the Republic of *Biafra*, and the Republic of *Oduduwa!*

(As in the Holy Prophecy, these are divine triplets – siblings from the same divine-love parental roots! Founded upon the sacred principle of *Self Discovery of the African Identity*, these Holy Nations of *Indigenous* Africa will flourish in divine self-accord as in peaceable spiritual *coessence* and harmonious cultural *coexistence!*

Established and existent upon the divine *Love of African Brotherhood* thus promotes healthy cultural interactions and wealthy social transactions as in idyllic ancient times ever before Nigeria was brutally "discovered" by the Colonial British through the political corruption of Feudal *Conquest* and military wickedness of Genocidal *Colonization*.)

The dream for ideal conditions of life where things work better than they do in Nigeria can only come true by a Higher Power of *Nationhood*. This must be much greater than the Lower Power of *Niggahood* by which Nigeria obtained its *civil clawhold* of Identity-*Undercultivationism*, and maintains its *evil gnawhold* of Character-*Underdevelopmentalism*, over its hapless *Captive* Nativities.

Only *Transcendental Power* can raise the African from *Street Agitator* in the Evil *Captivity* of *Niggahood*, onto the awing stature and status of *Imperial Conqueror* in the Civil *Liberty* of *Nationhood*. Only once spiritually empowered thus is he able to expel the Grand Evil which occupies his God-given Nativelands wreaking havoc there. *Transcendental Power* alone thus makes the difference and facilitates the *shift* from *Niggahood* Captivity to *Nationhood* Liberty, such that Niggahood cannot stand before their Civil *Excellence* except be put to flight before it. The *New Age* Mentation wields a spiritual vision of such *Transcendental Power* in the hands of subdued African Nativities of Niger Area.

If these *Indigenous Nations of New Age* Africa as resident in the *Holy Prophecy* were to be mere geo-political expressions (as Nigeria is), they wouldn't be worth the "change" that true Revolution should guarantee. There must be *Spiritual Power* vibrantly active in them for these *New Nations* to be worth it as the transcendental status of Civil-Liberty in *Nationhood* distanced from the satanical non-status of Evil-Captivity in *Niggahood*.

If it were in the Divine Scheme for the *Iniquity of Man* to exist unchallenged in perpetuating its perpetrated *Inequity* against Man, what mortal can challenge the Will of the Supreme Being thus? But once it becomes the Will of Supreme Being that the *Cessation of Iniquity* must be, there must be *Power* for the *Foundation of Dignity* in Nations of *New Age* Africa, such that *Iniquity* cannot but be put to flight before the *Dignity* of the People.

By the *New Age* Mentation thus, why should the mortal man bother with the way the world is, if it lies outside of his mortal failing to do anything about it? After all, as mere mortals, we only live here a

few months, so what's the big deal, and why bother with the world the way Supreme Being has in His Infinite Wisdom, designed that it should be?

However, if the need for Change is so acute – and spiritually significant – the best approach to meeting the challenge lies in total self-submission to the *Transcendent* Power, as to be mere vessels for It in catalyzing unfoldment of the *Divine Plan* on Earth. The *Revolutionary* thus must align himself with that Celestial Power, by which he acts as a conductor for It in *The Plan* to put *Iniquity* to flight in his domain.

Inequity where ever perpetuated, or *Iniquity* whenever perpetrated, rarely wakes up in the morning to voluntarily relinquish its evil dominion as it reigns. The *Revolutionary* thus must consciously seek *Celestial Power* and its *Cosmic Authority* to bring about the necessary *Change* in Niger Area. It would be foolhardy of mortal David to depend on his mere-mortal virtues, charging at Goliath without divine inspiration and empowerment. David can only fell Goliath once inspired and twice empowered by Supreme Being *Himself!* Such is the fullness of Spiritual Vision as resident in *New Age* African Thought for *Cessation* of the *Iniquity* of the Old *Country*, onto *Foundation* of the *Dignity* of New *Nations*.

Let us conclude herein that this thought-focus of *New Age* Africa remains disassociated with the fraudulent notion that ethnic and religious diversity disfavors institution of a virile *Nationhood* status, thus necessitating the break-up of Nigeria upon these fraud-sentiments. The *New Age* thought-focus rather confronts the fact that the foundation of Nigeria is so *massively flawed* it cannot be *altered* to create and build a *Real* Nation. Foundation that was created for a *cowshed* cannot be "upgraded" by any technology to support a *skyscraper*. That is the common sense logic of the *New Age* Thought inclining to *Peaceable* Dissolution and *Constructive* Liquidation of the corrupt-depraved, ailing-derailing *Colonial Relic* (a *cowshed*,) favoring institution of (*skyscrapers* in) *Indigenous Nations* of *New Age* Africa.

The truth is that *Nigeria* is so massively flawed ideologically and structurally as a (non-)status of *Nationhood* that it cannot be *restructured* or *rebranded* – or any such fraud as some may claim to be the solution to its pathological non-identity and pathetic non-directionality. This would suggest that any genuine effort at fundamental redress of any significance must culminate in *elimination* (as in *extirpation and extermination*) of that Massive Flaw. Total cure is always more valuable than mere palliatives.

Revolution will not rend-mend the Feudal *Corruptology* of Nigeria, neither will *Evolution* pamper Nigeria for its Genocidal *Corruptocracy!* Revolution rather seeks total *regenerative extirpation* of that *Faulty Foundation* inhibiting the African existence from Identity *Cultivation*, which is as well a *Massive Flaw* inhabiting the African experience against Character *Development*.

Existentially speaking, the *regenerative* break-up of the old-ailing, corrupt-putrescent *Colonial Relic* restores a superior fresh-start as on the clean slate of Indigenous Nations of *New Age* Africa founded on a level of spiritual ethics as of *Purity of the African Identity*, being as well of cultural esthetics as of *Originality of the African Character*. This divine status of *Purity-Originality* lies totally *superior, extraneous and transcendental* to the civil fraudulence of Nigeria's maniacal Ideological *Artificiality,* and the evil violence of its draconical Cultural *Superficiality!*

Chapter Four
VOLUME ONE OVERVIEW

Introduction to Volume One
THE CESSATION OF INIQUITY

Preface to Volume One
THE POWERED VEHICLE

Book 1
THE TRANSCENDENTAL DESTINY
1 Evolution of Democracy – 2 The Group Destiny – 3 Indigenous Consensus
4 The Power of Vibration – 5 Icons of Democracy – 6 The Transparency Test
7 Despair and Succor – 8 The Gallant Revolution

Book 2
TRAVESTY OF DEMOCRACY
1 Nigeria's Total Failure As A Democracy – 2 The Centrifugal Democracy
3 Why Nigeria and America Can Never Be Friends – 4 The Daft Constitution
5 Underdevelopment of the Nigerianist – 6 The Mission of Democracy in Nigeria

Book 3
NIGERIANISM: AN EXISTENTIAL PATHOLOGY
1 The Demopath – 2 The Termite Attack – 3 Apartheid Nigeria –
4 Bondage of the Nigerian People – 5 The Pathological Existence –
6 The Existential Quagmire – 7 Iniquity of Man

Richard Igiri

> Summary of Volume One
> APOCALYPSE NIGGATOPIA
> 1 The Transcendental Destiny – 2 Travesty of Democracy
> 3 The Existential Pathology – 4 Apocalypse Niggatopia

(i) The Cessation of Iniquity

European Colonialism was not about "discovery" of great Nations in Africa that could stand in *equal* status and stature of *Humanity* against Europe. The Colonial Master rather set out to "discover" *inferior, slave* "nations" to be eternally diminished in servitude to his own interests. These "nations" (such as "Nigeria") were thus "discovered" in the existential context of Military *Subjugation*, Political *Domination* and Cultural *Denigration* – for Economical *Exploitation*. The African Identity thus "discovered" into the *Iniquity* of artificial "nationhood", wallows in its pathetic Existential *Contradiction* hard-locked in its vicious circle of barbarism and futility.

Luckily, the *Old World* era of *Slavery and Colonialism* has come to its spiritual *nonessence* and cultural *obsolescence*: it becomes thus quite possible to achieve liberation from its *Post Traumatic Stress Disorder* ("Nigeria") through peaceful and creative maneuvers such as institute political and social structures which resonate the spiritual and cultural precedents of the *New Age*.

It was only *European Colonialism* that "discovered" and "partitioned" artificial-colonial "nations" in which the African Identity languishes in *Evil Captivity*, with the African Character equally anguished. Thus the ill-advised posturing that these colonial states "cannot" and "must never" be *rediscovered* by the African himself to reflect *Indigenous* beliefs that liberate his spiritual potencies; and thus *repartitioned* by the African himself to favor African survivalism that equally liberate his cultural potentialities, is a gearing of the *Colonial Mentality*. The imprudent and mechanical belief that such a *regenerative* thrust of events spontaneously summon military cataclysm, is representative of ideological toxins that intractably asphyxiate the colonized, held-captive, African mind.

The whole truth on the contrary is that the *New Age* prospect of Spiritual *Awakening* of the African Identity to *Self Discovery* into the Civil *Liberty* of *Indigenous Nations of New Age Africa* is not an invitation to political rancor and military strife among Nativities of each pathetic "nation" once "discovered" into its non-status of *Iniquity*.

Thus, "Let us identify and resolve our Existential *Contradiction* like thinking adults" is not the same as "Let us sweep the Contradiction under the carpet, quarrel and fight over the same Problem like impetuous children (without actually resolving it)!"

The African Identity who enters this status of *mental elevation* is said to be basking in the exalted psychological status of *Self Discovery*. This *resolved* mental realm of the *New Age African Identity* is one of *Revolution* within, as in the Holy Prophecy.

Revolution thus is the *renewing* of the African mind as leveraged in concentrate creative visioning in Identity-Existence, as well as its individuate maturity-constructivism in Character-Experience, through which may *Rise* Indigenous Nations of New Age Africa in their dignity of *Civil Liberty*.

(ii) The Powered Vehicle

Democracy as a *Powered Vehicle* suggests that this Sacred Ideal of existence and experience must be solicited and elicited, as well as found and founded upon the spiritual *Aspiration* resident in *Indigenous* enclaves as onto the pristine Nationhood status.

In its total spiritual *Sanctity* and absolute cultural *Sacrosanctity* thus, *Democracy* is non-supported in the ideological non-definition configured in the African existence and experience as "Nigeria". As a product of hate-complexes and contempt-reflexes of superior-conqueror Imperial Lords over their inferior-conquered slaves and subjects in Africa, this quasi-nationhood non-status (Nigeria) was, is and remains nothing but the burden as of a *"Post Traumatic Stress*

Disorder" inherited from *Slavery and Colonialism*. The *Iniquity* of these structures clearly contests, as well as contends-against the *Dignity* of sacrosanct Democracy as of pristine Nationhood.

That the divinity of holistic *Democracy* may be restored in the African existence and experience, it must be configured as a sophisticated *Vehicle of Destiny* thus *self-powered* by the ideals of *Indigenous* Survivalism as of *Self Discovery* of the African Identity.

When "democracy" becomes a *Wooden Cart* as in the Nigeria experiment (thus as opposed to a *Powered Vehicle,*) with "tires" of rounded plank, its quasi-motionality brutally and artificially *induced* from without the spiritual and cultural *Aspiration* resident in Indigenous enclaves, the satanic trajectory of its quasi-motionality thus would serve other designs and interests directly antithetical to the *Manifest Destiny* for the African Identity.

(iii) The Transcendental Destiny

> The *Transcendental* Destiny is the destiny of Spiritual *SelfIdeation* and Cultural *SelfCreation*, in which IdentityExistence basks reveled in *Cultivationism-&-Developmentalism*, being as in the Transcendental *Liberty-of-Nationhood.*
>
> This lies as fundamentally opposed to, and as radically distanced from, the *Satanical* Destiny of Feudal *Intimidationism* and Genocidal *Impositionism*, in which CharacterExperience masks leveled in *Undercultivationism-&-Underdevelopmentalism*, being as in the Satanical *Captivity-of-Niggahood*.

The significance of this concept in the Holy Prophecy addresses that being an *experiential non-status* of *Intimidationism-&-Impositionism*, Nigeria is *not* a *Transcendental* Destiny as of an *existential status* of *SelfIdeationism-&-SelfCreationism*. The *Transcendental* Destiny favors the Civil *Liberty* of the *Purity*-of-Identity and the *Originality*-of-Character. The *Satanical* Destiny harbors the Evil *Captivity* of *Artificiality*-of-Identity and *Superficiality*-of-Character. The

Satanical Destiny celebrates Economical *Pillage*, Social *Spoilage*, Political *Harlotry* and Military *Sorcery*. In the historical perspective, could not these evils of Existence-&-Experience be totally characteristic of *Nigeria?*

(iv) Travesty of Democracy

Continuing with the previous analogy, if the United States of America could be described, as well as defined, as a Transcendental *Transparency of Democracy*, which favors Identity *Cultivationism* in Existence, this would derive from the fact that America was, is, and shall be, a transcendental status of IdentityExistence basked-reveled in Spiritual *SelfIdeationism* and Cultural *SelfCreationism*.

By contrast thus, if Nigeria could be described, as well as defined, as a Satanical *Travesty of Democracy*, which harbors Character *Underdevelopmentalism* for Experience, this equally would derive from the fact that Nigeria was, is, and shall be, a satanical non-status of CharacterExperience masked-leveled in Feudal *Intimidationism* and Genocidal *Impositionism*.

If once thus pitched on its own *Civil* Path as a Transcendental *Liberty of Nationhood*, America was, is, and shall be, a creation of Spiritual *SelfIdeationism* and Cultural *SelfCreationism*, being as in the Civil *Liberty of Nationhood*. America thus qualifies, a *Transparency of Democracy*.

If twice thus ditched in its own *Evil* Path as a Satanical *Captivity of Niggahood*, Nigeria was, is, and shall be, a fabrication of Feudal *Intimidationism* and Genocidal *Impositionism*, being as in the Evil *Captivity of Niggahood*. Nigeria thus disqualifies, a *Travesty of Democracy*.

> Therefore, total *Creative Dissolution* of its Political Powerstructures of Feudal *Harlotry, Error*-Rained, as well as absolute *Constructive Liquidation* of its Military Powerbases of Genocidal *Sorcery, Terror*-Reigned, divinely constitutes in the African Sphere-of-Existence, the holy *Transparency of Democracy*, being as opposed to demonically instituted in the African Theater-of-Experience, an unholy *Travesty of Democracy*.

In Volume 2.*Summary*.14 titled *Redefinitions*, the Sacred Verses of the Revolution argues that *Democracy* does not mean free and fair elections. The divine logic is that if free and fair elections were to actually become culture in a society that is not free, with a polity that is not fair, where would that leave the Sacred Ideal of *Democracy*, except in total barbarization?

Nigeria owes its foisted-upon existence to *Intimidationist* Feudal Conquest and *Impositionist* Genocidal Colonization. We can see so clearly that these unholy "principles" upon which Nigeria was "discovered", are principles that are hostile to, as well as infertile for, the Sacred Principle of *Democracy* – being as in its total Spiritual *Sanctity* and absolute Cultural *Sacrosanctity!* The "Nigerian" had no say, neither any way, in the satanic process of the "discovery" and name-tagging of *Nigeria!* Therefore until such a time as the Nigerian becomes empowered (as in *Self Discovery of the African Identity*) to actually *SelfIdeate* his own Existence and *SelfCreate* his own Experience, he is nothing but a prisoner, held-hostage in a Satanical *Travesty of Democracy* – far-alienated from the Transcendental *Transparency of Democracy!*

(v) The Existential Pathology

a. Tale of Woe

Is it possible that all life were a tale told by an idiot, full of sound and fury, signifying nothing?

But it is quite possible that all *Nigerianism* were a *Tale of Woe* as told of the African Existence-&-Experience by a typical idiot, full of *Political* Sound and *Military* Fury – signifying absolutely *nothing!*

b. Satanical Virulence of the Existential Pathology

Nigerianism thus constitutes in the African Sphere-of-Existence an Existential *Pathology* of such satanical virulence as – Corruptology-&-Corruptocracy, Inequity-&-Iniquity, Extortionism-&-Exploitationism, Fraudulence-&-Violence, Pillage-&-Spoilage, Perversity-&-Adversity, Sin-&-Savagery, Harlotry-&-Sorcery; Feudalism-&-Genocidalism, Turbulence-&-Pestilence, Instability-&-Insecurity; Constrictionism-&-Restrictionism, Undercultivationism-&-Underdevelopmentalism; Infectionism-&-Afflictionism, Morbidity-&-Moribundity, Nonessence-&-Obsolescence; Artificiality-&-Superficiality – *Negativity-&-Futility.*

c. Demonical Violence of the Experiential Patheticity

Nigerianism further institutes in the African Theater-of-Experience, an Experiential *Patheticity* of such demonical violence as – Commodity-*precede*-Ideology, Ordeals-*subvert*-Ideals, Vice-*vanquish*-Virtue, Vermin-*violate*-Virgin, Iniquity-*cower*-Dignity, Mediocrity-*rule*-Genius, Imbecile-*teach*-Intellectual, Thief-*buy*-Chief, Malfeasance-*contain*-Eufeasance, Dysfunction-*guide*-Eufunction, EvilCaptivity-*define*-CivilLiberty, Reaction-*contain*-Revolution, Soldier-*swim*-Oil, Mutiny-*make*-Unity, Savagery-*seal*-Sovereignty, ArmedDictatorship-*author*-UnarmedDemocracy, North-*gobble*-South, Sinner-*sermonize*-Saint, Zero-*zap*-Hero – Satan-*lord*-Christ.

d. The Pseudotopia

What is the biggest fraud of the Nigeria Existence? Thus, what is the absolute *Number One Fraud* of the Nigeria Existence, upon which every other Feudal *Fraudulence* springs, as devilishly powered by its Genocidal *Violence?*

The *First Fraud* of the Nigeria Existence, being as in the Absolute Number One Fraud of *Nigerianism,* could just be the "Unity" between the *Civil* South and the *Evil* North (and conversely *Civil* North and *Evil* South). If it were possible, true Unity, being as in its total Spiritual *Sanctity* and absolute Cultural *Sacrosanctity*, remains divine and beautiful. But when Unity becomes politically *Feudal*, it is founded on its Civil *Fraudulence*; and when Sovereignty is militarily *Genocidal*, it is pounded-on by the Evil *Violence*, of a *Pathological* Existence.

Nigerianism is hatred of Truth. Nigeria thus, remains a passionate hater of Truth. The Nigerianist, who claims that "Unity" between the North and South is pristine and sacrosanct, has already lied. The Nigerianist, who would have us believe that such Unity actually exists, is already burdened with the guilt of telling a Lie – the *Lie of Nigeria*. The Fraudulence-&-Violence, as well as Artificiality-&-Superficiality of this satanical scenario of the African Existence-&-Experience, would explain that the emergent Nigerian must remain by nature and character, a peddler of lies and frauds in order to survive and thrive in the World as "Nigerian". The First Fraud so brutally slammed hard on his mind's construction through Nigeria's Political Unity ridden of Feudal *Fraudulence*, and its Military Sovereignty driven by Genocidal *Violence*, makes the Nigerianist an ignoble personification of Fraudulence – a *Living Lie*.

In the *Degenerativism* of such a satanical scenario of Existence-&-Experience, the First Fraud produces the Second Fraud, and the Second Fraud produces the Third – *et cetera*. Such "Nigerianism" usually runs through the plot of one's favorite movie. The villain, who perpetrates a hideous felony, must ingeniously craft other heinous felonies to conceal the Initial Felony. In this way, we see the Nigerianist entangled in a web of political Lies, economical Frauds, and military Atrocities – which satanically constitute the Fraudulence-ridden Political Unity, as demonically institutes the Violence-driven Military Sovereignty, of a *Pathological* Existence.

We might add that the satanic buzzwords of Nigerianism "zoning" and "quota" constitute respectively, institutionalization of the First Fraud of the Civil *Error* of Nigeria's *Turbulent* Political Unity, and the Initial Felony of the Evil *Terror* of its *Pestilent* Military Sovereignty. The satanic buzz words "zoning" in its Political *Harlotry* thus, and "quota" in its Military *Sorcery*, institutionalize respectively, the Feudalism of its *Artificial* Unity, and the Genocidalism of Nigeria's *Superficial* Sovereignty.

As far as the Civil *Fraudulence* of its *Feudal* Politicism goes, and the Evil *Violence* of its *Genocidal* Militarism thus, Nigeria remains a passionate hater of realism and Truth, at once a romantic lover of Pseudism and Falsehood. Its *Fraudulence*-ridden *Feudal* Unity and *Violence*-driven *Genocidal* Sovereignty, between the North and South, remain at best a mere nigga-glamorization of the fundamental *Untruth* of an Existential *Pathology* – being as in nigga-ceremonization of the Pseudism of a *Pseudotopia*.

e. The Niggaphenomenon

The *Niggaphenomenon* consists of the *Niggaschism*, the *Niggadilemma* and the *Niggamorphism*. These three toxic elements of *Nigerianism* thus constitute the nigga-phenomenality of the satanical virulence – being as well of the demonical violence – of an Existential *Pathology*.

i) The Niggaschism

Nigerianism is a satanical conspiracy against the transcendental process of total *Actualization* of *Ideals*-of-Existence. The niggasophisticationism of this Existential *Pathology* founds its demonic pride upon *Subversion-of-Ideals* of IdentityExistence, being as in its *Submersion-in-Ordeals* for CharacterExperience.

On the Sacred Path of *Actualized* Dreams, Nigeria constitutes a huge stumbling block, which the African Identity-&-Character must contend with, and surpass, one way or another. That which consistently *separates* the African Identity-&-Character from Existential *Idealization*, is Experiential *Ordealization* in *Nigeria*. Languished in this *Subversion-of-Ideals*, the African Identity-&-Character hopes and gropes in vain onto Transcendental *Nationhood*, being as anguished thus by *Submersion-in-Ordeals*, as of Satanical *Niggahood*.

In classical *Nigerianism*, there is no bridge ready-constructed to safe-pass the African Identity-&-Character from Evil *Captivity* in *Negative* Reality, onto Civil *Liberty* in *Positive* Dream. There is no bridge in Nigerianism thus between *Captivity* and *Liberty*, but only *schism* – being the *chasm*-impediment which keeps Identity-&-Character violently torn and separated from the status of Escape from the Undesirable *Real* onto the Desirable *Ideal*, in the *Highest Thing It Can Be*.

In this satanical scenario of the African Existence-&-Experience, the *Schism of Niggahood* separates Identity-in-Civil*Liberty* from Character-in-Evil*Captivity*. The *Niggaschism* thus remains the unbridgeable chasm of classical *Nigerianism*, which perm-seats between *Inspired* Transcendental Nationhood, and *Impaired* Satanical Niggahood. In the *Niggaschism,* Character swallows anguished in *Fixture-&-Seizure* as of the Ordeal-of-*Niggahood*, as Identity wallows languished totally violated and negated onto its Ideal-of-*Nationhood*.

As a satanical virulence of the Existential *Pathology*, the *Niggaschism* equally takes demonical manifestation in the *rift* between North and South. This Existential *Pathology*, being as of the Niggahood-*Schism*, manifests as the Feudal *Fraudulence* of its Unity between the *Civil* South and the Genocidal *Violence* of the Sovereignty of the *Evil* North. This subverts aspiration to *SelfIdeationist* Cultivationism in IdentityExistence, as restrained by *Impositionist* Underdevelopmentalism in Character Experience.

The *Niggaschism* further rears its ugly head in the foul chasm between the *Past* and the *Future*, by which Identity-&-Character languishes *Caught*Up-&-*Held*Down in *Political Precepts* of Experience from the *Colonial Past*, and thus wallows disabled for accession to the *Spiritual Concepts* of Existence as of the *Technological Future*. In the *Schism-&-Chasm* of this Existential *Pathology*, the Niggahood *Ordeal* of the *Colonial Past* cannot so neatly be collapsed as to conveniently fold-in into the Nationhood *Ideal* of the *Technological Future*.

(vi) Apocalypse Niggatopia

Niggatopia, thou Political *Sodom*, Military *Gomorrah!* What tarriest thou upon the face of Mother Africa, than rest in thy beastly chains, cast into the Dragons' Deep beneath the deep, brown-green sea whereat thou fittest?

Niggatopia, Feudal *Harloterer*, Genocidal *Sorcerer!* Thou shalt rise in thy foul morn to be greeted by a cup of period. According to thy evil dealings in Sodom-*Harlotry* and Gomorrah-*Sorcery*, Niggapetrodollar-*Pillage* and Niggasuperpower-*Spoilage*, shall be reapen unto thee. Thou shalt not sow hate and strife, to reap love and peace; but even as thou sowest shall the foul legion of thy niggapetrodollar-niggasophisticationism come fallen to thy portion in Apocalypse Niggatopia, onto *Cessation!*

Niggatopia, Iniquity of Man! Blackman's corruption in the Feudal *Crookedness* of Civil *Harlotry* against his brother Blackman. Thy Evil *Sorcery* pitches against thy brother in Genocidal *Wickedness*. Even as thou wallowest in the satanic pride of thy demon-niggapetrodollarism, thy sole Heaven-ordained portion surely lies in immutable *Cessation!*

Chapter Five
VOLUME TWO OVERVIEW

Introduction to Volume Two
THE FOUNDATION OF DIGNITY

Preface to Volume Two
MILITARY UNINTELLIGENCE

Book 1
THE NEW GROUND
1 Individualism – 2 The Technological Society – 3 Generation Clash – 4 Video Value
5 Democratization of Militarism – 6 The Zoom-Lens Effect – 7 Beyond the Ethnic Barrier

Book 2
THE SACRED PATH OF NATIONHOOD
1 Analysis of Nigeria's Corruptology – 2 SelfDiscovery – 3 Revolution – 4 Tribal Dynamism
5 Truth and Reconciliation – 6 The Nationhood Psychology – 7 The Old Man of Badagry

Book 3
REVOLUTION OF BIAFRA
1 Revolution of Biafra – 2 Existential Supremacy of Biafra Over Nigeria – 3 The Way of Biafra
4 Monolog of the Biafran Soldier – 5 Ode to the Biafran Soldier – 6 Dignity of Man

Summary of Volume Two
LAND OF THE RADIANT SUN

> 1 The Cake-Baking Process of Transcendental Nationhood – 2 The Seed of Greatness – 3 Horns, Tail, Fork 4 Pathological Philosopher, Pathetical Philosophy! – 5 Paradise and Superparadise – 6 Recertification of Nationhood – 7 The Common Man – 8 Outburst of the Common Man – 9 The Second Premise Biafra
> 10 Ashes of Defeat – 11 The Lingering Future – 12 Points of Radical Departure – 13 Let Us Rise, Or Ever Sit 13b Let Us Rise – 13c I Am Involved – 14 Redefinitions – 15 The Full Extent of Democracy
> 16 The Trigger Nigga – 17 The Dream of Israel – 18 My Humble Prayer

(i) *The Foundation of Dignity*

As Darkness and *Nescience* cannot stand-against the blazing-forth of Light and *Science, Iniquity* thus cannot but be diminished and extinguished at the emergence of *Dignity.*

Thus, the "discovered" *Iniquity of Man* must come to *Cessation* in the African Theater-of-Experience once the *Dignity of Man* through Self Discovery comes to *Foundation* in the African Sphere-of-Existence.

(ii) *Military Unintelligence*

The Old World Order institutionalized rifts and splits among Peoples of the Earth and Nations of the World in its espoused military psychology – nay, psychopathy! It was the Orient and the Occident, Master-Nations and Slave-Nations, Blacks and Whites – suggesting ultimately Validity and Invalidity – thus locked in the animal race to be better armed-to-the-teeth the one over his other.

This satanic stereotype of military unintelligence thus defined espoused values for the "discovered" slave nations in Africa. The Imperial psychopathy thus pursued armed-to-the-teeth Independent unintelligence among "discovered" African Nativities postured for mutual self-destruction as definition of the "nationhood" status.

Aspect of Revolution in Nigeria

When the potential for military cataclysm is consciously and intently etched into the "discovery" process and foundation philosophy of a "nation", where then lies Democratic Intelligence for Development except Military Unintelligence institutionalizing armed-to-the-teeth, the Unity and Sovereignty of intractable Underdevelopment?

(iii) The New Ground

Volume 2.1 of the Holy Prophecy titled the *New Ground,* begins with *Individualism*. The Sacred Verses espouses *Individualism* as a divine status of *Maturity* in the African Identity. This is as sharply contrasted with the demonical non-status of *Immaturity* in the African Character – as lies totally resident as well as operative in *Nigerianism. Individualism* and *Nigerianism* represent *Value* and *Non-value* as employed in the Sacred Verses for depiction of *Nationhood* and *Non-nationhood* (*Niggahood*).

All in the divine spirit of "*Debate* Nationhood" than "*Dictate* Niggahood" in hard-pursuit of *Self Discovery* of the African Identity, the *Holy Prophecy* comes up with several logical reasons favoring *Creative* Dissolution and *Constructive* Liquidation of the *Colonial Relic* onto Indigenous Nations of *New Age* Africa. Herein the Sacred Verses employs symbolism which thrusts *Nigerianism* upon us as spiritually hollow and negative, as well as culturally *subversive* and indeed *submersive*, onto Transcendental *Nationhood*.

Let us briefly consider one or two of these good-logic sound-reasons favoring *Dissolution* and *Liquidation* of the non-status of Satanical *Niggahood* if the African Identity and Character must accede to Transcendental *Nationhood* as espoused in the Sacred Verses.

In the following verses of Volume 2.1.1 titled *Individualism*, the *Holy Scriptures of the Revolution* bemoans thus –

30 A parent or fostering guardian chooses clothes for the infant under their care. It is their duty to do this after their inclination for preferences, but in total disregard of the fact that the infant under their care has (latent) *Individuality*, and therefore must be given to a definite bent for preferences. An infant all too soon no longer an infant faces the reality of having to acculturate the uniqueness and fashionability of *Individualism*. At adolescence or adulthood proper, the infant garments once chosen for it by the Guardianship (*Nigerianism*), quite naturally cannot continue to be fashion, being as totally out-grown, *Worn-&-Torn* into its necessary *Nonessence-&-Obsolescence*.

31 Once an infant under Guardianship, yet presently emergent onto Adulthood having to face the adult responsibility of self-determination, the human personality thus must turn versed in the art to *SelfIdeate* spiritually, as well as *SelfCreate* culturally, being as upon the hallowed *New*Ground of *Individualism*. In this transcendental scenario of *Individuation* of Identity-&-Character (as into *SelfIdeationism-&-SelfCreationism*), it becomes the inalienable Right of the *Individual* to self-design vesture, having graduated from being under Guardianship (and especially one of such satanically adamant niggasophisticationism in Harlotry-&-Sorcery, Suppressionism-&-Oppressionism, Undercultivationism-&-Underdevelopmentalism, being thus as satanically constitutes *Nigerianism*).

31b Onto total transcendence of *Nigerianism* thus, *Individualism* stirs by verve, onto Activity-&-Creativity, for Congruity-&-Continuity, Idealization-&-Harmonization, being as upon a *New*Ground of IdentityExistence and CharacterExperience.

32b As against the backdrop of the *Old*Earth of *Captivity-to-Chance* thus (being as *Smeared*On onto Identity in Virulent Impositionist*Error*, and *Foisted*Upon Character by Violent Intimidationist*Terror*), the *Liberty-of-Choice* as to the *Individuated* inclination for preferences, becomes Existence under the Spiritual*Creativism* of the Bluesky*Sanctity*, and Experience upon the Cultural*Dynamism* of the Whitesands*Sacrosanctity*, of the *New*Ground.

33 The infants' garments now vastly out-grown, their fabric and print an embarrassing oddity in the esthetics of the contemporary order, Identity-&-Character alone thus, being as totally emergent onto *Individualism*, may choose the pattern of *Regeneration* appropriate for emergence onto relevance in the cultural realities of the *New*Ground it must learn to tread. Thus having out-grown the fraudulent and impositionist, violent and intimidationist Guardianship of the *Old*Earth, and for the reality of the Planetary flux of cultural clime and trends, Identity-&-Character must reserve the inalienable Right to the *Liberty-of-Choice* as to *Revolution in Ethics* for Politics, and *Evolution of Esthetics* for Civics, whose *New*Winds continue to exhilarate the breath-of-man upon the *New*Ground.

33b *Individualism* thus cannot be emergent onto *Dynamism-&-Creativism* in Existence-&-Experience, except a new fabric is spun for its adornment, a new print made, and a new cut sewn, being in their unison which resonate the transcendental *Regenerativism* of the *New*Ground of IdentityExistence and CharacterExperience.

34 *Reality* remains in flux, and unceasingly. The Law of *Activity-&-Creativity* in Existence, as well as of *Congruity-&-Continuity* for Experience, necessitates as compels Identity-&-Character to innovate equally unceasingly, that pace and faith may be kept with, than be blurred-out to *Reality* thus, as manifest for IdentityExistence and CharacterExperience. All-grown-up thus, totally emergent unto *Individualism*, Identity-&-Character cannot endure burdened with the imposed-on bearing as of the *Institutionalized*Infancy (as in "Nigeria"). In the *Regenerativism* of this transcendental scenario of *Individualism*, Identity-&-Character cannot be restrained thus *Frozen-&-Fossilized* in the *Nonessence-&-Obsolescence* of its *Institutionalized*Infancy, than be melted into the *Sanctity* of the Bluesky*Liberty-&-Activism*, as well as *Sacrosanctity* of the Whitesands*Dignity-&-Creativism,* of the *New*Ground.

35 *Individualism* thus inclines the *Captive*Nativities of Nigeria toward a sociopolitical status extraneous and transcendental to the political *Restrictionism* of Nigeria's *Impositionist*Unity, as well as the cultural *Constrictionism* of its *Intimidationist*Sovereignty.

35b A *Law of Life* thus lies non-existent which decrees absolute-eternal *Nigerianism* over *Individualism* for the African IdentityExistence wallowed in its Civil*Subversionism* thus, that the Political *Rigger*Nigga alone may Pillage-&-Spoilage in Authoritatrian*Error.* The Law of Life neither favors CharacterExperience swallowed thus into Evil*Submersionism,* that the Military *Trigger*Nigga may Shoot-&-Loot by Totalitarian*Terror.*

Aspect of Revolution in Nigeria

36 *Individualism* thus humbly seeks through legitimate processes of Sacrosanct*Democracy, Abolition-&-Dissolution, Demolition-&-Liquidation,* of the *Republic of Captivity,* as onto total Identity*Extrication* from the Feudal*Impositionism* of its Political*Inequity,* as well as Character*Evacuation* from the Genocidal*Intimidationism* of its Military*Iniquity.* It would amount to the worst existential monstrosity of radical Contention-Against the Activity-&-Creativity of *Individualism* for the African IdentityExistence and CharacterExperience, that these Nativities were so Held*Hostage* in the Virulent *Rains of* Civil*Error,* as well as in the Violent *Reigns of* Evil*Terror,* being as of this *Pathological*Existence.

36b *Individualism* thus seeks total Extrication-&-Evacuation of Identity-&-Character from *Suffocation* in the *Infectionism,* as well as *Asphyxiation* in the *Afflictionism,* of this cess-pooled *Old*Earth Experience, being as onto the Bluesky*Vivacity,* and the Whitesands*Vitality,* of the *New*Ground Existence.

38b Wherever *Individualism* is seen thus stirring among these Nativities, it must be divinely condoned as constituting budding Transcendence of the *Satanical*Destiny of Intimidationist*Undercultivationism,* being as well of Impositionist*Underdevelopmentalism.* Identity*Emasculationism* in the *Cave of Captivity,* as well as Character*Disillusionment* in the *Chains of Chagrin,* divinely predicate the totally legitimate Divine*Aspiration* of Identity-&-Character thus to a transcendental status extraneous to *Nigerianism's* Suffocationism-&-Asphyxiationism, Vegetationism-&-Relegationism, as of the *Old*Earth of Experience. This lies as onto *Individualism's* Vivacity-&-Vitality, Generation-&-Regeneration, Sanctity-&-Sacrosanctity, as of the *New*Ground of Existence.

39 It must be recalled that Nigeria was originally "ideated" for, as well as "created" thus, only for *Illiterate* Natives who had achieved no measure of *Individuation* in the *Ethics of Existence,* and most certainly neither in *Esthetics for Experience,* as apparent to their European conquerors and rulers. And thus came created the illiterate *"Niger Area",* for *Unindividuated* ("Uncivilized") Natives just barely literate enough to produce raw materials for Europe's Industry. This satanic Entity thus came into its pathological existence for that negative purpose only: the mass-manufacture of *Industrial*Niggas to serve Industrial Europe as the loftiest essence and significance of its "sovereign" niggasophisticationism.

In the foregoing we can see very clearly that the *Holy Book of the Revolution* writes off *Nigeria* as a piece of garment sewn for an *institutionalized* child, but a grown man who should have outgrown it by *wisdom,* is still wearing it in *ignorance.* How does he hope to prosper in the spiritual and cultural realities of the adult world, still wearing an old, out-dated, worn-and-torn garment of his *institutionalized* childhood?

As in the *Divine Psychology* thus, *Revolution* necessitates that the old tattered garment of *Nigerianism* be *abandoned,* salvaging the African Character from the *"Old* Earth" of experience. The African Identity thus *dons* the new garment of the glory of *Individualism,* for activity and creativity in trends of the *New* Ground of existence.

Another logical reason the *Holy Prophecy* offers in favor of *Dissolution* and *Liquidation* of the corrupt-putrescent *Colonial Relic* for emergence of *Indigenous* Nations of *New Age* Africa concerns population management technologies. A good question any intelligent person should ask is: In terms of ideological foundation and governmental intellectualism – which run in *deficit* in the Nigeria experiment – can Nigeria boast population management technologies such as cater for 150 million African people, as in *cultivation*-of-the-African-identity and *development*-of-the-African-character, onto spiritual and cultural standards of the 21st century?

The answer is a resounding, capitalized *No!*

Spiritually and materially, "Nigeria" has no power of *cultivation-of-identity* and *development-of-character* for 150 million African people of diverse world views and cultural backgrounds. The only power of *cultivation* and *development* for its Peoples that a *Nation* may wield is that which it *generates*. Nigeria *does not* generate spiritual *power* or cultural *ideas* of any *creative* kind to build these Peoples into the status of true *Nationhood*. It has only the niggahood-pride of total-dependence on its *niggapetrodollarism* to lay a politically *fraudulent* (and a militarily *violent*) claim to the existential status of *Nationhood!*

The *Holy Prophecy* thus strikes at the vital and pivotal issue of *population management technology* for *Cultivation* of the African Identity, and *Development* of the African Character, onto Transcendental *Nationhood*.

Regarding population management technologies, in Volume 2.1.6 titled *The Zoom-Lens Effect,* the *Holy Scriptures of the Revolution* says in the following verses –

> 17 The Zoom Lens *Effect* further harbors a Population Management Technology for *Cultivation* of the African IdentityExistence, and *Development* of CharacterExperience thus. The *Creative*BreakUp of Nigeria thus unfetters Identity-&-Character to its *Undercultivationism-&-Underdevelopmentalism* as a satan-branded product of population-explosion and crowdedness in the Nigeria*Failure,* which lies well-beyond the niggasophisticationism of its Shootership*Lootership* to address.
>
> 17b The Zoom Lens *Effect* of the *RegenerativeBreakUp* of Nigeria is one of emergence of population-effective Nations of the *New*Order. Each *New*Nation emergent thus divinely basks in the *Individuated* (Developed) population-*management* status, being as opposed to the *Crowded* (Underdeveloped) population-*undermanagement* non-status as in the *Undercultivationist*Unity and *Underdevelopmentalist*Sovereignty of the Nigeria*Failure.*

17c Upon the *New*Ground thus constituted of the African IdentityExistence and CharacterExperience, the emergent *New*Nations divinely revel unburdened of a *Bedlam of Tribes* demonically leveled in the Confusionism-&-Contentionism of discordant tribal identities such as satanically constitutes the Nigeria*Failure*. The *New*Nations thus divinely bask in their *Civil*Liberty with fewer tribal identities hoarding *Conflicting* interests in the Society and Economy, while boarding *Confronting* schemes in the Polity and Military.

17d The Civil*Regenerativism* of such a transcendental scenario of the African Existence-&-Experience harbors fewer tribal identities to cater for ideologically, and far fewer populations to cater for socioeconomically. These populations thus *Individuated* in the ZoomLens*Effect* of their *RegenerativeBreak-Up*, divinely revel better elevated by quality of life as contrasted with what obtained in the Evil*Degenerativism* of a typical *Bedlam-of-Tribes*, inhabiting uncatered-for crowd-populations satanically wallowed in *Feudal*Undercultivationism and demonically swallowed in *Genocidal*Underdevelopmentalism.

17e The ZoomLens*Effect* thus harbors the total-impeccable *Evacuation* of African*Nativities* from Tribal*Crowding* in the *Old*Earth of Satanical*Niggahood*, to total-imperturbable *Actualization* onto National*Individuation* upon the *New*Ground of Transcendental*Nationhood*.

18 The *NigeriaExistence* remains much like animal vegetation in a crowded apartment for delinquent juveniles. Herein, adult concentration for adult creativism remains cast into subversion and infeasibility. Thus lies operative a totally *Degenerative* kind of crowding in which tribal personalities inclined to *Creativity* have no privacy for composure and concentration, without which they cannot secure total *Actualization* of the *Dynamism-&-Creativism* of *Individualism*.

Aspect of Revolution in Nigeria

18b In the satanical *Degenerativism* of such a *Bedlam of Niggahood* (a bedlam of pseudo-ideologies and techno-pathies, of *Conflicting* political inclinations and *Confronting* social orientations), these *Captive*Nativities merely *Vegetate* existentially in the *Maze* of the Civil*Barbarism* of *Undercultivationism,* and thus *Relegate* culturally in its *Daze* of the Evil*Demonism* of *Underdevelopmentalism*. Herein they wallow in the Evil*Captivity* of their CrowdMentality*Degenerativism* of the *Old*Earth thus, as totally negated to the Civil*Liberty* of the IndividuatedPsychology*Regenerativism* of the *New*Ground.

19 In the *Nigeria*Existence lies a pattern of *crowding* by which, figuratively speaking, full-adult members of a family inclined to different lines of personality-orientation live together. They so live together not in the Civil*Liberty* of a stately family mansion, but in the Evil*Captivity* of a dilapidated, dejected, crammed lone-room rented apartment. Noteworthy also lies that they do not so "live together" by an act of the Frugal*Choice* of Civil*Excellence*, but are only so yoked-up by the Brutal*Chance* of Evil*Violence.*

19b In this kind of crowding, a personality-type may wish to study during a certain hour of the day, and the other sees the occasion fit only for loud revelry. The *Nigeria*Existence remains this pattern of the Niggahood*Chaos,* than could ever "develop" into Nationhood*Cosmos* of any kind. The incompatibility of their pursued desire-patterns as well as the irreconcilability of their personality-rearings in this *Durance-of-Niggahood*, can only get worse as they get older and facilities once in mere obsolescence, degenerate further into Total*Collapse.*

20 The personality-types so held-hostage in this kind of a negative and unproductive family situation, could have lived together pretty well in their respective Infant*Inclination,* but as full-adults and each having "branched-off" into their Adult*Orientation*, only naturally must take to their own independent-adult *Walk of Life* in their own families thus *Individuated.*

20b The *Mass*Mentality otherwise, would have the *Captive*Nativities perpetuatedly-*Wear* in the *Artificial*Unity, and perpetratedly-*Tear* in the *Superficial*Sovereignty, of their CrowdedLoneRoomApartment. But the *Individuated*Psychology (being a *Divine*Psychology,) inclines that in *Evacuation* of the AfricanCharacter from Evil*Captivity* in the CrowdMentality*Underdevelopmentalism* of the *Old*Earth, lies total *Actualization* of the AfricanIdentity onto Civil*Liberty* in the IndividuatedPsychology*Cultivationism* of the *New*Ground.

21 The *Nigeria*Existence as a school dorm wallows in such a pathological *Degeneration-&-Dilapidation,* which lies as a function of its *Crowd*MentalityNiggasyndrome. Assuredly, no decent parent would want their kids sent to "Nigeria" to learn *Nigerianism* becoming one of its graduate-celebrities. Instead of *Form-&-*Develop the AfricanIdentity, this *Pathological*Existence can only further *Deform-&-*Underdevelop the AfricanCharacter in the *Tatteredness-&-Raggedness* of its *CrowdMentality*Niggasyndrome.

21b This Existential*Pathology* of Identity*Degradation* and Character*Deformation* only warps the human personality with complexes of wretchedness and indignity, of debasement and failure. This *Tatteredness-&-Raggedness* of the *Mass*MentalityNiggasyndrome of the *Old*Earth Experience deserves total *Extirpation-&-Extermination* onto *Cultivationism-&-Developmentalism* as of the *Individuated*PsychologySyndrome of the *New*Ground Existence.

(iv) The Sacred Path of Nationhood

In Volume 2.2 titled *The Sacred Path of Nationhood*, the Holy Prophecy dwells upon the context of *Planetarism*, which transcends – even negates – *Nationalism*. The Divine Prophecy herein argues that the *Fall of the Berlin Wall, Abolition of Apartheid, Collapse of*

Communist USSR, have created an *New* World Order of *Planetarism*, casting into its obsolescence, *Nationalism* as the veritable premise for *Nationhood* in its divine *Integrationism*. The Divine Prophecy thus concludes that the "nationhood" of Nigeria which predicated ideologically and politically on *Nationalism* as a function of the *Segregationism* of the *Old* World Order, comes to its total-nonessence and absolute-obsolescence in the *Integrationism* of the *New* World Order.

In *The Sacred Path of Nationhood,* verse *c.*, the Holy Scriptures of the Revolution says –

> c. The *Evolutionary* changes of pre-millennial 1989 and thereabout, which upturned the OldWorld*Disorder* of *Nationalism*, thus created in its transcendental wake a *New*WorldOrder of *Planetarism*. The divine denotation of *Evolution-&-Revolution* as in the *Fall of the Berlin Wall, Collapse of Communist USSR, Construction of the Channel Tunnel, et cetera*, lies in that the societies of *Colonial*Europe whose cultures have residued *Colonial*Relics like Nigeria, *no longer exist.*

Herein the *Holy Book* seeks rouse our attention to the fact that owing to her imperial stability, Europe has continued to grow and develop in total self-transcendence such that her image as the *Colonial* Master has been cast to total obsolescence. The true spiritual significance and cultural relevance of such breakthroughs as *Fall of the Berlin Wall* and *Construction of the Channel Tunnel* is such that spiritually and culturally, the nascent *New* Europe of today is a far cry from the obsolescent *Old* Europe of the *Colonial* Era.

The spiritual and cultural dynamics of this *New World Order* lies thus such that calls to question the spiritual significance and cultural relevance of a "nation" deriving and predicating the totality of the pride of its "national" existence on being "discovered" in ideological and political contexts of *Colonialism* as espoused by *Old* Europe of the *Colonial* Era.

The *Holy Book of the Revolution* thus casts to negation the ideological context as well as cultural content of such a Colonial *Relic* as Nigeria for *cultivation* of the African Identity and *development* of the African Character, onto pristine *Nationhood* as obtains in the spiritual and cultural precedents of this *New World Order*.

In Volume 2.2.2, the *Holy Scriptures of the Revolution* also dwells upon *Self*Discovery as contrasted with *European*Discovery. Herein the Holy Prophecy favors that on the Sacred Path of Nationhood, *"Self*Discovery of the African Identity" is better than *"European*Discovery of the African Character". Only when the African Identity achieves Discovery of its own *Self*, can it be said to be totally situated upon the *Sacred Path of Nationhood*. But once the African Character depends on forces and caprices from without to "discover" it and call it a "Nation" (such as *Nigeria*), only the opposite of *Nationhood* (*Niggahood*) obtains in such a satanical scenario of existence.

In verses 9-11, 13-14b and 15 of Volume 2.2.2 titled *Self*Discovery, the Sacred Verses of the Revolution enlightens us thus –

> 9 *European*Discovery came along with *name-tags* of the *Old*Order such as *Toby* and *Nigeria*, which demonically harbor the *Underdevelopmentalism* of Satanical*Niggahood*. But the AfricanIdentity by *Self*Discovery thus must come to *real-names* of the *New*Order – such as *Kinte* for example – which divinely favors the *Cultivationism* of Transcedental*Nationhood*. Alone thus in *Self*Discovery divinely basks the African Identity-&-Character pitched in total-impeccable justification upon the Sacred Path of *Nationhood*.

10 The AfricanCharacter at once thus must power-out of the *Underdevelopmentalism* of *European*Discovery, being thus as for the AfricanIdentity onto the *Cultivationism* of *Self*Discovery. The AfricanCharacter must *lose*-out of the Evil*Captivity* of *European*Discovery into the Underdevelopmentalism of *Nigerianism,* being that the AfricanIdentity may *choose*-in to the Civil*Liberty* of *Self*Discovery into the Cultivationism of *Individualism.*

11 The *Divine*Psychology thus admonishes the African Identity-&-Character in the *Dynamism-&-Creativism* of the *New*Order, "You must *invent!*" The AfricanIdentity must *Self*Ideate its own Existence in *Cultivationism,* as the AfricanCharacter alone thus must *Self*Create its own Experience in *Developmentalism,* being as onto Transcendental*Nationhood.* Identity thus must *Self*Author *Cultivationist*Existence, as Character alone must *Self* Finish *Developmentalist*Experience.

13 On the Sacred Path of *Nationhood,* the *Power of Vibration* through *European*Discovery of the AfricanCharacter as *Toby,* satanically configures *Underdevelopmentalism* for Experience, even as upon *Self*Discovery of the AfricanIdentity as *Kinte,* lies divinely configured *Cultivationism* in Existence. *European*Discovery thus demonically ditches the AfricanCharacter in the Evil*Captivity* of Satanical*Niggahood,* being as in *Nigeria.* *Self*Discovery alone thus divinely pitches the AfricanIdentity in the Civil*Liberty* of Transcendental*Nationhood,* being as in the *Arewa* Republic, the *Biafra* Republic, and the *Oduduwa* Republic, divine-concepts.

13b This Divine*Triplets* once brought to total *Actualization* in the African Sphere-of-Existence and Theater-of-Experience, constitute the *Footstools of God on Earth* for *Cultivation* of the AfricanIdentity into Spiritual*Liberty,* as well as *Development* of the AfricanCharacter into Cultural*Dignity,* being as of Transcendental*Nationhood.*

14 What a tragedy of the African Existence-&-Experience that the totality of the niggasophisticationism of *Nigeria* pitches upon no earth holier than its *Trail-of-Destruction* in IdentityExistence, as well as *Pile-of-Ruins* for CharacterExperience, as of *European*Discovery. But the transcendental abracadabra of *Self*Discovery seals the divine feat of Healing-of-the-Wound of Feudal*Conquest* of the AfricanIdentity, being as well of Erasing-of-the-Scar of Genocidal*Colonization* of the AfricanCharacter, through *European*Discovery.

14b *Self*Discovery further thus divinely impacts total Identity*Evacuation* from the Trail-of-Destruction as constituted in Existence through *Conquest*, being as well absolute Character*Evacuation* from the Pile-of-Ruins as instituted for Experience through *Colonization*.

15 While *European*Discovery continuingly *ditches* the AfricanCharacter in the *Underdevelopmentalism* of the Evil*Captivity* of the Demonic*Ditch* of Satanical*Niggahood*, *Self*Discovery alone thus *pitches* the AfricanIdentity in the *Cultivationism* of the Civil*Liberty* of the Divine*Beach* of Transcendental*Nationhood*.

In Verse 9 of *Self*Discovery, the Holy Prophecy is simply saying that *Nigeria* is equivalent to a name-tag given by the White *Master* to his Black *Slave*, which destroys his true *Identity* and burdens him with a false *Character*. This name tag ("Toby" as in Alex Haley's *Roots*) emasculates the African *Slave* making him totally subdued to his conqueror, slave-toiled in self-impoverishment only to enrich the White *Master*.

According to the *Divine Prophecy*, the African Identity cannot do without insisting upon his true Name (*Kinte* as in *Roots*), alone which brings him to any semblance of total-situation upon the *Sacred Path of Nationhood*. Thus while *European*Discovery ditches the African Character in *Niggahood* such as *Nigeria*, only *Self*Discovery pitches the African Identity in pristine *Nationhood* as obtains in *Holy Nations*

of New Age Africa such as the *Arewa* Republic, the *Biafra* Republic and the *Oduduwa* Republic.

A chief attribute of the divine status of *Nationhood* is *mental reality*. The mental reality of the status of *Nationhood* is such that the citizens of that Nation love that Nation and would *willingly* live *or* die for it. Being as a demonical non-status of *Niggahood*, Nigeria has no *psychological realism* and *mental reality* such that its citizens would *willingly* live *or* die for. The mental reality of Nigeria goes only as far as what *Evil* Influences of niggahood those who *Shoot* Nigerians can wield, as well as its *Civil* Affluences which those who *Loot* Nigeria can amass. Beyond such niggapetrodollar *Nigerianism*, what mental reality has Nigeria of the divine semblance of *Individualism*?

In verses 44-44c, 45 and 46 of Volume 2.2.6.c titled *Mental Matrix of Nationhood*, the Holy Scriptures of the Revolution divinely admonishes –

> 44 The *Nationhood*Craft at once crystallizes in a *Matrix* of *Subjective*Conscience as of Existence*Idealism*, which translates into an *Objective*Consciousness of Experience*Realism*. In the *Regenerativism* of this transcendental scenario of Existence-&-Experience, construction of the *Nationhood*Craft as founded in the inviolability of Subjective*Idealism*, facilitates it grounded thus upon the infallibility of Objective*Realism*.

> 44b The *Nationhood*Craft thus must derive the *Authoritative*Predication of *Physical*Experience upon its *Authentic*Premise of *Mental*Existence.

> 44c It becomes thus only logical that the *Nationhood*Craft must at first be *Authentically*Cultivated in *Mental*Purity, as thus predicates and validates *Authoritatively*Developed in *Physical*Originality.

> 45 On the Sacred Path of *Nationhood*, construction of the *Nationhood*Craft lies totally akin to the transcendental process of construction of craft of any designation such as a bridge or a ship. The Mental*Matrix* of the craft in each instance must be *crystallized* without whose Subjective*Idealism* (as in the *Mental,*) its Objective*Realism* (as in the *Physical,*) cannot but be elusive.
>
> 46 The Mental*Matrix* of *Nationhood* in its impeccability must be Spiritually*Ideated* in *Conscience*Existence, being as in its inviolability Culturally*Created* in *Consciousness*Experience, as onto Transcendental*Nationhood*.

The Holy Scriptures of the Revolution thus herein opines that for a *Nation* to have true *Authoritative Physical* Experience in terms of fulfilling dreams for its citizens, it must have an *Authentic Mental* Existence. The Holy Prophecy further brings it to our attention that a *Nation* must be founded upon the Mental *Purity of Identity* for it to have the Physical *Originality of Character.*

These transcendental virtues of existence and experience clearly elude *Nigeria*.

The *Holy Prophecy* thus warns that a *Mental Matrix of Nationhood* must be crafted, that the African Identity and Character may have any hope of ever achieving total situation upon the *Sacred Path of Nationhood*. But the truth being that Nigeria boasts no such transcendentalism, we must look *beyond* Nigeria to find such divinity. This divine quest would normally take one as far as the *United States of America*, the *European Nations, Japan, China, India* – or very close within – *Arewa, Biafra, Oduduwa!* These Great Nations, far and near, are hugely endowed of divinity thus. Only *Nigeria* is devoid of such transcendentalism!

Now, who is the *Old Man of Badagry?* In Volume 2.2.7 titled *The Old Man of Badagry,* the Sacred Verses tells the pathetic story of the Old Man of Badagry.

Aspect of Revolution in Nigeria

1 The *Colonial*Masters in far-away Europe scrambled for the *partitioning* of Africa. And at the very end of it all, *European*Nations became proud owners of *Slave*Nations in Africa. But *African*Nativities lost it all: the *Old Man of Badagry* for one, was the most-violated as an African *Native*.

2 *Longitude*This and *Latitude*That (purely imaginary lines "seen" only by pure-white *Europeans!*), which split up *Native* Homelands of Africa into *Colonial* European "Nations", had split up his family home-grounds into "partitions" that became – by *Conquest-&-Colonization* – extensions of a myriad of European language groups and nationalities.

3 The large traditional family-room thus became the "territory" of one *European*Nation with its own distinct European language and culture, as surely as the detached-kitchen "territory" in the family compound became the shadow-effect "nation" of imperial Europe with its own quasi-European language and culture.

4 The family room, private rooms, kitchen area, the barn area, even the cultivated farmlands surrounding the house had been sliced up into meaningless "partitions" most uncreatively leveled out in meaningless "amalgamations". These became "territories" and "Nations" belonging to everyone else in far-away Europe, except the *Old Man of Badagry* in Africa. Where was *his* own *Territory* and *Nation*?

4b Poor Old Man!

5 The poor *Old Man of Badagry* daily bemoans his precipitated non-status of *Arrest-of-Identity* through *Conquest*, as well as of his *Loss-of-Character* through *Colonization*. Who on earth would believe – especially after his much-celebrated "Independence" – that he is actually *Mired-&-Quagmired*, yet intractably *Bogged-&-Dogged* in the Satanical *Captivity of Niggahood*, being as wallowed within these *partitions* of Ideological*Artificiality* in the African IdentityExistence, and swallowed in their so-called "nations" of Cultural*Superficiality* for the African CharacterExperience?

9 In the Trauma-&-Stigma of *European*Discovery into Satanical*Niggahood*, the *Old Man of Badagry* thus wallowed totally divested of all *Purity-of-Identity* and *Originality-of-Character*, became a sociopath. In the Psychopathy-&-Sociopathy of his satanical non-status of Independent*Niggahood*, the *Old Man of Badagry* could perpetrate a felony in the Kitchen Area of his Family Compound, and would escape the Law of the *Artificial*Country into the Barn Area – since he would have smartly figured that each of these partitions had become separate "Sovereign States" each with its own types and sets of *Artificial* Laws of the Land!

10 This would explain that most of what was "discovered" as "Africa" took to impropriety as in Social*Barbarism*, Economical*Vandalism*, Political*Harlotry* and Military *Sorcery* – in frantic efforts to close the unholy chasm between Identity*Purity* and Character*Originality* in Transcendental*Nationhood*, and Identity*Artificiality* and Character*Superficiality* in Satanical*Niggahood*.

11 The *Old Man of Badagry* thus "discovered" into the Spiritual*Plight* of his *Arrest-of-Identity,* and thus into the Cultural*Blight* of his *Loss-of-Character*, the African Existence became merely *Pathetical* as a Political*Mire* of its Civil*Harlotry*, as his African Experience became squarely *Pathological* as a Military*Quagmire* of its Evil*Sorcery*.

Aspect of Revolution in Nigeria

12 Political*Barbarism-&-Harlotry*, as well as Military*Demonism-&-Sorcery*, became the loftiest definitions of "Nationhood" and "Sovereignty" for "Africa" thus "discovered" into *Niggahood* and *Savagery*.

13 On the Sacred Path of *Nationhood* thus, the *Old Man of Badagry* nurses the divine *Aspiration* to the status of *Self*Discovery into the *Liberty of Nationhood*, being as brought to total *Actualization* in Existence-&-Experience through the Creative*Dissolution* of these Political*Powerstructures* of Civil*Error-&-Harlotry*, as well as in the Constructive*Liquidation* of their Military*Powerbases* of Evil*Terror-&-Sorcery*, which were satanically instigated upon the African Existence-&-Experience through *European*Discovery.

14 The *Old Man of Badagry* thus divinely basks in his Spiritual*Aspiration* to the Transcendental *Liberty of Nationhood* in *Real*Nations of the *New*Order, being as in the *Arewa* Republic, the *Biafra* Republic and the *Oduduwa* Republic, divine-concepts.

The trauma and stigma of *European* Discovery into Satanical *Niggahood* is such that the Old Man of Badagry became divested of all humanity as of Identity *Purity* and Character *Originality*. Disoriented and destabilized thus (as in divested of *Nationhood* and cast into *Niggahood*), the Old Man became sociopathical – not to mention *nigga-psychopathical!*

The (false) attempt to close the unholy chasm of *Niggahood* between "as I have been discovered (into Character *Superficiality*)" and "as I truly am (in Identity *Originality*)" accounts for existential malaises in Africa as of Social *Barbarism*, Economical *Vandalism*, Political *Harlotry* and Military *Sorcery*, which became nigga-institutionalized as (Nigeria) "Nations" in Africa.

But of course, the Old Man of Badagry daily dreams of an existential status of *Self*Discovery into true and *Real* Nations of *New Age* Africa such as the *Arewa* Republic, the *Biafra* Republic and the *Oduduwa*

Republic. He would at least have his entire family estate restored to his *real* name in one holy piece of *Nationhood*, wouldn't he?

And so, back to the trillion dollar question, Who is the Old Man of Badagry?

Well, if we must address it literally – the *African Identity-&-Character* languished-anguished in *European* Discovery into Satanical *Niggahood!*

For the African Identity-&-Character thus demonically wallowed in the Evil *Captivity* of *European*Discovery into Satanical *Niggahood* in *Nigeria,* only *Self*Discovery into the Civil *Liberty* of Transcendental *Nationhood* in the *Arewa* Republic, the *Biafra* Republic and the *Oduduwa* Republic, *is it!*

(v) Revolution of Biafra

In the preliminary verses of Volume 2.3 titled *Revolution of Biafra,* the *Holy Scriptures of the Revolution* confronts the student of the Revolution with a subtle and advanced elucidation of the sacred-concept *Revolution.*

> c. Once pursued in the Evil*Violence* of its *militarist* definition, *Revolution* fails woefully as to yield Divine*Change* in the African Sphere-of-Existence and Theater-of-Experience. The continuing pursuit of Civil*Excellence* alone secures *Revolution* of the totally *Regenerative* order: Evil*Violence* of its self otherwise assures its perpetrated *Degeneration* of IdentityExistence in *Negativity*, as well as perpetuated *Degradation* of CharacterExperience in *Futility*.

cb. The Spiritual*Essence* and Cultural*Quintessence* of *Revolution* thus lies in total *Actualization* in Existence-&-Experience, alone in the totally *harmonious succession of events* as divinely constitutes the *Regenerative*, being as in total negation of the semblance of *cataclysm*, which demonically institutes the *Degenerative*.

d. *Revolution* necessitates *Imbibed* in Identity, a totally *Regenerative*Conception of Existence, as well as *Imbued* in Character the wholly *Regenerated*Perception of Experience. *Revolution* once thus divinely *Solicited* in the *Idealized*Conscience for Conception-of-Existence, and thus *Elicited* in the *Harmonized*Consciousness of Perception-of-Experience, alone constitutes *Dynamism* in Existence, as institutes *Creativism* for Experience. *Revolution* thus thrives Identity onto its *Zest*-of-Dynamism for *Congruity* in Existence, as well as drives Character onto its *Crest*-of-Creativism for *Continuity* of Experience.

e. *Revolution* as Determined thus in the Spiritual*Conscience*, and Defined in the Cultural*Consciousness* of Transcendental*Unism*, tears asunder Evil*Violence* for Incongruity-&-Discontinuity of Experience, and Civil*Excellence* onto Congruity-&-Continuity of Existence. This transcendental scenario of *Congruity*-in-Existence and *Continuity*-of-Experience thus, totally negates secular zealotry as in pursuit of mere transient fancies of ideology. Thus divinely basks *Conscience-&-Consciousness* empowered with Stoicism-&-Sangfroid, being as to await Transcendental*Science* in Civil*Excellence*, than brew in a hurry Satanical*Nescience* by Evil*Violence*.

f. *Revolution* in Existence for *Congruity* at first Constitutes in *Subjective*Idealism, after which Institutes in Experience for *Continuity* of *Objective*Realism. This represents the *Divine*Dualism of *Revolution-&-Evolution* as in the *harmonious graduation* of the One*Historical*Existence* in *Congruity*, onto Another*Cultural*Experience of *Continuity*.

g. The totally *Congruous*Revolution in IdentityExistence thus consummates alone in the wholly *Continuous*Evolution of CharacterExperience. This transcendental status of Existence-&-Experience lies that of perpetuated *Regenerativism* in the *Civil*Excellence of Identity, being as in negation of perpetrated *Degenerativism* as of *Evil*Violence in Character.

gb. "Life will find a way" (as in *Life's* tendency to Get*On* in spite of all odds) remains thus a *Law of Life*, which divinely *Impels* Identity in *Revolution* onto its *Zest* of SpiritualExistence, as *Propels* Character by *Evolution* onto its *Crest* of CulturalExperience.

h. Onto *Congruity* in Existence favoring the Spiritual*Zest* of Identity, the *Revolutionary* must Find A Way to become the *Evolutionary*, as onto *Continuity* of Experience harboring the Cultural*Crest* of Character.

hb. Identity-&-Character thus comes to the *Awakening* that *Life* has its own way of *Civil*Excellence in mending its own Rends and healing its own Wounds, which negates *Evil*Violence in its totality.

hc. In this transcendental scenario of *Conciliationism*, the *Evolutionary* pursues the harmoniously graduated Change in Transcendental*Unism*, while eschews *Confrontationism* for cataclysmic Change as of Satanical*Dualism*.

i. Thus quite unlike the rambling *Revolutionary* with no grounding in *Subjective*Idealism, the effaced *Evolutionary* simply learns to Walk*With* the *Evolutionary*Trend of Existence-&-Experience, being thus which favors *Cultivation* of the Spiritual*Essence* of Identity onto *Congruity*-in-Existence, as well as harbors *Development* of the Cultural*Quintessence* of Character onto *Continuity*-of-Experience, in Transcendental*Nationhood*.

Aspect of Revolution in Nigeria

j. As aquatic surges erode rocks after their wave-patterns as impinged upon these, thus lie the rock-calcification of *Negativism-&-Degenerativism* over Identity-&-Character eroded by *Evolution* after patterns of its *Creativism-&-Regenerativism*.

k. *Evolution* thus eroding Character*Negativism-&-Degenerativism*, etches-on Identity*Creativism-&-Regenerativism*. But yet, *Conscience-&-Consciousness* must *Awaken* to this transcendental process of *Idealization-&-Harmonization*, being as onto *Crystalization* of the Spiritual*Essence* of IdentityExistence in *Congruity*, as well as *Consolidation* of the Cultural*Quintessence* of CharacterExperience in *Continuity*.

l. In this transcendental scenario of *Creativism-&-Regenerativism* thus, *Revolution* merely "revolves" the Spiritual*Essence* of *Identity*Existence onto *Congruity*, as *Evolution* only "evolves" the Cultural*Quintessence* of *Character*Experience onto *Continuity*.

n. The *Revolution of Biafra* thus paints a transcendental scenario of the African Existence-&-Experience in which Identity-&-Character *matures* to *Self*Discovery onto Transcendental*Nationhood*. This lies as in its total *Extrication-&-Evacuation* from *immaturity* in *European*Discovery into Satanical*Niggahood*.

o. *Biafra* thus remains the ultimate-paradigm *Epic-of-Triumph* as told of the African Existence-&-Experience. The African Identity-&-Character once satanically *Caught*Up and twice demonically *Held*Down in a *Tale-of-Woe* as conspired in *European*Discovery into Satanical*Niggahood*, aspires thus to *Self*Discovery onto Transcendental*Nationhood*.

p. As against the AfricanCharacter once demonically propelled through *European*Discovery into Satanical*Niggahood*, *Biafra* remains the ultimate archetype of the AfricanIdentity twice divinely impelled by *Self*Discovery onto Transcendental*Nationhood*.

Richard Igiri

The Holy Prophecy favors Revolution as a *harmonious succession of events* onto *Regenerative* Change, which negates cataclysm as in the *Degenerative*.

The Holy Book equally favors Revolution as *Cultivation of Conscience*, such that Identity imbibes Civil *Excellence* to await Transcendental *Science*, than wallow in *Underdevelopment of Consciousness* by which Character pursues Satanical *Nescience* in Evil *Violence*.

Evil *Violence* produces *Incongruity* and *Discontinuity* in Character Experience, while Civil *Excellence* produces *Congruity* and *Continuity* in Identity Existence. This is *Revolution*.

Revolution of Biafra thus is a transcendental scenario in which the African Identity *matures* to *Self* Discovery in Civil *Excellence*, being as opposed to the *immaturity* of the African Character in *European* Discovery into Satanical *Niggahood*, wreaked through Evil *Violence*.

Indigenous Nations of New Age Africa such as the *Arewa* Republic, the *Biafra* Republic and the *Oduduwa* Republic thus remain the divine-status of Existence in which the African Identity achieves *Self* Discovery into the Civil *Liberty* of Transcendental *Nationhood*, being as opposed to a demon-status of Experience in which the African Character languishes anguished in *European* Discovery into the Evil *Captivity* of Satanical *Niggahood* – as in *Nigeria*.

In Volume 2.3.2 titled *Existential* Supremacy *of Biafra Over Nigeria*, the Holy Scriptures of the Revolution sets out several points of the existential and ideological *Superiority* of *Biafra* to Nigeria. Thus put in other words, Nigeria's ideological *inferiority* to Biafra – and the rest of the *Indigenous Nations of New Age* Africa as revealed in the *Holy Prophecy* such as the Arewa Republic and the Oduduwa Republic.

By summary let us say that an *experiential* non-status in which the African Character is "discovered" from outside Africa and name-tagged "Nigeria" is *inferior* to an *existential* status in which the

African Identity achieves *Self*Discovery and calls itself *Biafra* (or *Oduduwa*, *Arewa* as the case may be).

Alternatively, an *existential* status in which the African Identity achieves *Self*Discovery, self-naming itself *Biafra*, is *superior* to an *experiential* non-status in which the African Character is "discovered" from outside Africa and slave-named "Nigeria". Therein lies the total-incontrovertible existential *Supremacy* of *Biafra* as a transcendental status of *Self*Discovery of the African Identity in *Nationhood*, over Nigeria as a satanical non-status of *European*Discovery of the African Character in *Niggahood!*

Chapter Six
POETRY IN REVOLUTION
ঔ৳

Summary of Volume Two is titled *Land of the Radiant Sun*. This round-up of the *Sacred Verses* boasts several pieces of poetry, which aims to express the spiritual content of the Holy Prophecy more vividly and intimately. *Revolution* is so heart-felt in these Sacred Verses that only the mystical power of poetry could catalyze the divine process of actualization of its spiritual Vision in existence, as well as its cultural Mission for experience.

I would fervently dispute such sentiments of our high-tech world of today, suggesting that poetry is obsolete and out of the scheme of things. Many who espouse these sentiments exhibit so much ignorance of the actual nature of our hi-tech world of today. But the true nature of our hi-tech world of today is that it *runs* on poetry!

No one needs to go as far as Mozart, Haydn, Beethoven – or Shakespeare – to find poetry. Just listen to a heartfelt Mariah Carey or Brandy Norwood song, and then dare opine that minims and crotchets are obsolete in our hi-tech world of today! The salient and incontestable fact that there are values of life which do not change in spiritual significance, nor do ever depreciate in cultural relevance – relative to time lapse and social advancement – speaks in favor of poetry in our everyday life experience.

Take a look at a computer motherboard. The etchings you observe on the circuit board are in fact pure and unadulterated *poetry!* Consider how important the computer is in running those little but critical tasks upon which daily existence and survival in our high-tech world of today depends. The mystical tales on every circuit board of hardware, as well as the cultic codes which constitute software, are all forms

of *poetry!* Consider it from that perspective and be amazed how that the world *runs* on poetry!

The power of poetry is such that a Dream poetically expressed serves as a *decree* issued to the Elements of *Life* to produce such a Dream right onto manifestation.

In Volume 2.3.3 the Sacred Verses of the Revolution poeticizes upon the *Way of Biafra* –

> 13 Thou dost ask, Whereat lieth the Way of Biafra?
>
> 13b I answer thee thus: Give thou that which lieth in thy possession!
>
> 14 Beloved*Pilgrim*, art thou possessed of three spoons, rarely needing thy fourth? *Give* thou that which lieth in thy possession onto thy brother in need of it. Deny thyself but severely if need be, that thou mayest uplift thy brother pilgrim. Alone thus in giving of thyslf lieth the *Way of Biafra* divinely paved onto the Transcendental *Liberty of Nationhood!*
>
> 14b Sacrifice alone thus may *Concentrate-&-Consecrate* the Dynamism-&-Creativism of *Liberty* in Existence, as Sacrifice alone yet may *Generate-&-Regenerate* the Vivacity-&-Vitality of *Dignity* for Experience!
>
> 15 Beloved*Pilgrim*, by Sacrifice – even as a kind word to thy brother in need – alone thus mayest thou plant thy feet pitched upon the *Way of Biafra*. Thy sacred tread thus upon the holy cobblestones of the *Way of Biafra*, conductest thee through the embellished portals monumental, onto the *Sacred*City of Biafra!
>
> 16 Thou dost ask, Whereat lieth the Way of Biafra?
> 16b I answer thee thus: A Will and A Way –

17 Beloved *Pilgrim*, where lieth a *Will*, sleepest thus a *Way* – always. The *Will* onto *Biafra is* the *Way of Biafra!* Upon the divine imperativeness of the Transcendental *Liberty of Nationhood* – as against the Satanical *Captivity of Niggahood* – lieth thus the *Way of Biafra!*

17b Upon the will of Civil*Survivalism* in *Dignity* against the Evil*Antagonism* of *Iniquity*, lieth the *Way of Biafra!* Beloved*Pilgrim*, were there no *Will* for *Biafra* in IdentityExistence, would be there no *Way* of *Biafra* for CharacterExperience!

18 The *Will* for *Biafra* thus lieth in *Revolution of Biafra* in *Subjective*Existence, as the *Way* of *Biafra* lieth in the *Evolution* of *Biafra* for *Objective*Experience!

18b The *Will* for *Biafra* thus secureth *Idealization* of IdentityExistence, as the *Way* of *Biafra* lieth onto *Harmonization* of CharacterExperience! In the transcendental *Regenerativism* of the *Way of Biafra* thus, Celestiality-&-Terrestriality, Creator-&-Creation, mayest come to total Spiritual*Sympathy!* Identity-&-Character, Survivor-&-Survivalism thus equally mayest gravitate onto absolute Cultural*Symbiosis!*

18c The *Will* for *Biafra* in IdentityExistence thus, sealeth in its divinity the *Way* of *Biafra* for CharacterExperience, onto the *Holy*City of *Biafra!*

44 *Thou dost ask, Whereat lieth the Way of Biafra?*
44b *I answer thee thus: the Look Inwards –*

45 Beloved *Holy*Pilgrim, the Look*Inward* perfecteth in personality re-orientation onto the Sacred *Legend of Biafra* in the African IdentityExistence and CharacterExperience! Thus divinely constituteth, *Beloved*Pilgrim, thy total-impeccable justification onto the transcendental status of the *Nationhood*Liberty, being as in total Extrication-&-Evacuation from the satanical non-status of the *Niggahood*Captivity!

46 By the renewing of thy mind in the Look*Inward* thus, seek not the *Way of Biafra*, O *Holy*Pilgrim, in the Satanical*Dualism* of *Objective*Experience: rather tread thou the sacred cobblestones of the *Way of Biafra* in the Transcendental*Unism* of *Subjective*Existence!

46b The Look*Inward* thus, seest the "I" by essence, as the noble *Way of Biafra!*

47 Seek not, Beloved *Holy*Pilgrim, the *Way of Biafra* in *Objective*Realism, except rather take the *Holy*City of *Biafra* in *Subjective*Idealism! Beloved*Pilgrim* thus, thou requireth *Dream* Biafra in thy dreams!...*Think* Biafra in thy thoughts!...*Feel* Biafra in thine emotionality!....*Speak* Biafra in thy tonality!... *Act* Biafra in thy mannerism!... *Live* Biafra in thy styles!...and yet *Be* Biafra by thy *Faith!*

48 Thus, *Twice*BlessedOne, lieth the *Way of Biafra!* The Transcendental *Liberty of Biafra* lieth thus brought to total *Actualization* for IdentityExistence and CharacterExperience through employment of the *CreativeImaging* faculty!

48b In the divinity of *CreativeImaging* alone thus lieth thy total-divine empowerment to live (in) the Transcendental *Reality of Biafra* in the *Now*Eternal! The Look*Inward* thus re-constituteth Identity-&-Character from Satanical*Captivity* in Degenerate*Animality* as of *Niggatopia*, onto Transcendental*Liberty* in Regenerate*Spirituality* as of *Biafra!*

49 Let not, *Holy* Pilgrim, the *Dragon of Niggatopia* steal thy self-value, nor yet still thy self-esteem! Guard thou but jealously, the supreme aplomb of thine imperturbable *Supremacy* over the *BlackDragon!*

49b The Look *Inward* to the *Dignity of Man* constituteth thy total Divine *Evacuation* from whining as a mere Victim of the *Iniquity of Man*, onto winning in Transcendental*Liberty* as the ultimate *Victor* upon the sacred cobblestones of the noble *Way of Biafra!*

49c As in the Look*Inward*, let thy personality re-orientation thus, as well as the psychological re-inclination thereof, tear asunder, O *Holy*Pilgrim, thy Civil*Liberty* of *Biafra*, and thy Evil*Captivity* in *Niggatopia!* Alone thus hard-pitches thy prince's feet upon the glazed-hallowed cobblestones of the *Way of Biafra*, onto the *Holy*City of *Biafra!*

70 Yet dost thou ask, Whereat lieth the Way of Biafra?
70b Yet I answer thee thus: Humility-&-Dignity!

71 Beloved *Holy*Pilgrim, the gait of war lieth foul, ponderously cumbersome. The gait of competition and confrontation, tedious and robot-like. The gait of anger and violence clattereth bones, wearing cartilage. The foul gait of angered armies lieth rowdy and unromantic, as yet coagulateth the humanity of men that they tread as though dead while yet undead.

72 The sacred cobblestones of the *Way of Biafra*, rendereth it thus with such celestial sheen which tosseth and spilleth the gait of war upon it. Tread not thus, O Holy*Pilgrim*, the clatter of bones, neither loss of cartilage, the unromantic gait of robot-willed creatures as to war. Upon the holy sheen of the sacred cobblestones of the *Way of Biafra*, O Holy*Pilgrim*, tread thou alone thus as the butterfly's humble perch upon nectared flowers!

73 Upon the sacred cobblestones of the *Way of Biafra*, O Holy*Pilgrim*, lieth *Flair-&-Romance!* The transcendental effervescence of the *Way of Biafra* thus exudeth in its divinity, celebration of transcendental virtues of Existence-&-Experience, as for *Fidelity-&-Fecundity!*

73b Being thus as the *Way of Compassion-&-Camaraderie*, the *Way of Biafra* lieth paved as the Way of Identity*Humility* and Character*Dignity!*

74 Wherefore BelovedHoly*Pilgrim*, tread thou aloft the *Way of Biafra* in the butterfly-perch gait-afloat of *Humility-&-Dignity!* Let the ecstasy of Romance-&-Camaraderie seize thy mien, Holy*Pilgrim*, as yet must thine pilgrim's soles press the divine glee thereof, into the glazed-holy cobblestones of the *Way of Biafra!*

74b Tread thou the gait of romantic anticipation, Holy*Pilgrim*, as onto a sweet-sacred rendezvous with the *Maiden of Bikini*, who tarrieth right through the florid portals of the *Holy*City of *Biafra!*

75 The *Way of Biafra* lieth the gleeful tread of *Romantic*Anticipation onto the divine rendezvous with the Fair*Maiden* of the *Holy*City! Let the breathtaking silhouette of the Fair*Maiden* of *Biafra* thus seize thy mentality, while yet to saturate thine emotionality!

75b Revel yet thou, O Holy *Pilgrim*, in flashed impressions of the divine affections aflame in thine heart, for the Fair *Maiden* who positeth right past the florid portals of the *Sacred*City of *Biafra!* In all Humility-&-Dignity thus return thine Immortal*Love* for the Fair*Maiden*, which grants thee no mood for Mortal*Hate*. Her sweet tenderness waiteth thee by Romantic*Anticipation* right through the *Embellished*Portals of the *Holy*City of *Biafra!*

76 The ponderous gait of war leadeth yet into more Civil*Lust* and Evil*Quest* as to be "won" by war. The *Way of Biafra* otherwise, favoreth the *Way of Freedom* from mortal *Lust-&-Quest*, O *Holy*Pilgrim, as yet harboreth the noble *Way of Freedom From Warfare!*

76b Upon the sacred cobblestones of the *Way of Biafra* thus lieth Transcendental*Liberty* in *Unism*, being as redeemed forth of Satanical*Captivity* in *Dualism*. The *Way of Biafra* divinely basketh thus the *Way* of butterfly-perch *Humility-&-Dignity*. This perfecteth in Existence the *Divine*Power which lieth at total-variance with *Vanity-&-Iniquity* as of the *Dark*Power in Experience!

> 77 Divinely glazed, the sacred cobblestones of the *Way of Biafra* casteth to total negation, the demonical stampede of war in *Aspiration* onto the Transcendental *Liberty of Nationhood* as of the *Holy*City of *Biafra!*
>
> 77b The *Way of Biafra* thus lieth the Way*Beyond* the Evil*Captivity* of Time-&-Space in Mortal*Warfare*, onto the Civil*Liberty* of Eternity in Immortal*Peace!*

The Holy Prophecy advises that such divine attributes as sharing, looking inwards in self-reliance, as well as humility and dignity, constitute the divine fuels that propel the Pilgrim upon the sacred cobblestones of the *Way of Biafra*, right onto the Holy City of *Biafra*.

In Volume 2.3.4.e titled *Woe Niggatopia!*, the Biafran Soldier laments thus –

> 1 Niggatopia! Niggatopia! Niggatopia!
> Thou foul entity (wicked!) without a soul!
> Thou the *Dignity of Man* dared who stole!
> The *Iniquity of Man* thy very vile sole!
> Demonical thou, grappler-with-God thy life role!
> Thy gargoyled name-sur tattoos equals Satan's mole!
>
> 1b Thy provision base, of the imbecile vast tainted!
> Thy privation haste, of the intellectual caste sainted!
>
> 2 Niggatopia! Niggatopia! Niggatopia!
> Thou Evil*Terror* who feeds and pampers *Iniquity*
> While out in the cold night's lone forsakes *Dignity!*
>
> 3 Niggatopia! Niggatopia! Niggatopia!
> Thou Civil*Error* who charades whores in teasing loom
> While virgins yet coy hide obscure in their dressing room!
> 4 Niggatopia! Niggatopia! Niggatopia!
> Thou Evil*Sorcery* who parades vile villains in splendors
> While brave heroes grave-anguished languish indoors!

> 5 Niggatopia! Niggatopia! Niggatopia!
> Thou *Niggahood*Dystopia who fetters brave erudites in squalor
> While thy spineless imbeciles roam unfettered in valor!
>
> 6 Niggatopia! Niggatopia! Niggatopia!
> Thou drinker of the blood of blameless virgins
> Slain at the foul swords of thy red vicious vermins –
> Whose demonical mutinies nourish the Civil*Error* of thy *Harlotry*
> With unities to furnish the Evil*Terror* of thy flagrant *Sorcery!*
>
> 7 I salute thee, say-hi thee, honor thee as were thine only due –
> Let thine *Crookedness-&-Wickedness* serve soap soaking thy rue!

We may also briefly consider this couple of pivotal poems, *Dignity of Man* and *Iniquity of Man*. *Iniquity of Man* closes Volume 1.3, while *Dignity of Man* closes Volume 2.3.

Iniquity of Man consists of 21 couplets and 42 verses. *Dignity of Man* consists of 12 couplets and 24 verses. Thematically, these poems are polar opposites, sharply contrasting with, as well as bouncing off of each other by the antithetical themes they address. These themes of course, remain the estrangement between *Dignity* and *Iniquity*, *Self*Discovery and *European*Discovery, Civil*Liberty* and Evil*Captivity* – *Nationhood* and *Niggahood!*

Poems in the Holy Prophecy include *Iniquity of Man, Outburst of the Common Man, Monolog of the Biafran Soldier, A Psalm of Biafra, Dignity of Man.*

Here are three couplets out of twelve from *Dignity of Man* –

> 1 *Biafra – Virginland of Virtue:* Mozart's orchestra chimes in forests ageless
>
> Onto the sacred heart of gods, this stirs mortals once seemed sageless

> 2 *Biafra – Maiden of Bikini:* seen with eyes shut, yet found fair
> As her breathtaking silhouette into my wearied heart did fare
>
> 12 *Biafra – Dignity of Man:* nulled to whine and die in Evil*Captivity* to The Dogs
> Hailed identity thus glorified to wine and dine in Civil*Liberty* with The Gods

In this poem the *Sacred Verses* speaks of *Biafra* in totally utopian terms! Imagine a Nation so beautiful that Mozart's orchestra is heard on the ceiling of ageless forests!

The second couplet likens *Biafra* to a Maiden of Bikini. *Bikini* is said to be a far-out fantasy island where "supermodels" and fantasy maidens bask in pristine beaches scantily clad in gaily colored swim-suits. Their swim-suits ("bikinis") are named after that fantasy atoll of the Pacific, called the Bikini Atoll. Imagine a woman so beautiful that even with one's mortal eyes shut, her hour-glass figure would haunt like a ghost on the inner vision of love!

In the twelfth couplet, the *Holy Scriptures of the Revolution* concludes that *Biafra* is an existential status in which man is delivered from *whining and dying* in Evil *Captivity* to The *Dogs*, which liberates him into *wining and dining* in Civil *Liberty* with The *Gods!*

As a super-archetype of *Indigenous Nations of New Age* Africa founded upon the transcendental bedrock of *Self Discovery of the African Identity,* what a poetical *Nation* this would be!

Chapter Seven
INDICES OF NIGERIA'S CESSATION

֍

A gentleman once wrote extolling Nigeria's virtue as the freest country in the world. Nigeria would appear founded on such total-freedom as dwarfs even the *United States of America* for her so-called "Liberty". Unbelievable miracles of personal freedom are a daily occurrence in Nigeria. Imagine a country so free that even when a *Legislootocrat* seals a feat of Nigeria's *Lootocracy* and raises a furor, he has freedom to simply *settle everyone* – and walk absolutely *free!* The furor dies a natural death and it's more personal freedom for lootership as usual!

Great minds have warned that Nigeria as we know it – with its opprobrious national non-standard of ethics and esthetics – is *yet* to clinch the *Nationhood* status. The truth is that the complacent and nigga-institutionalized *Sin* of Nigeria does not bode immortal Nationhood, but in fact portends negation of Nationhood. The niggapetrodollar pride of its "nationhood" is only an illusion which locks the African Character in the *Niggahood* of its self-annihilation portent!

Not too long ago I saw a movie titled *Poseidon*. In Greek mythology, Poseidon is the name of the god of the sea. In this action-packed, suspense-filled movie, *Poseidon* was the name of a luxury cruise ship, so-named after the sea god of Greek mythology. The movie features lovely "big girl" Fergie, who thrilled the cruise farers with her singing.

In that movie, this luxury cruise ship was at sea, thronged with passengers who were having so much fun on this cruise. Poseidon

was all of a sudden hit by a "rogue wave". This was a tsunami up to thirty meters tall, coming out of nowhere and right in the middle of an otherwise imperturbable sea.

The captain saw this eerie wave approaching, but all too late. He made every professional effort to steer the ship away from the rogue wave, but it had crept up close enough to impact Poseidon. So devastating was this "rogue wave" when it finally did impact Poseidon that she keeled over in a few hours, floating upside down.

For how long could Poseidon float *upside down* in the middle of the sea?

Many of the deluded among the crew and passengers continued to believe and hope that Poseidon would not float upside down indefinitely, and that help was just around the corner. A certain architect accustomed to scientific thinking had advised "These things are not designed to float upside down". The foolish and unscientific continued to argue against the urgent need to contrive an escape route of some sort *upwards to the bottom* of Poseidon (The bottom of Poseidon was now several decks *upwards* in its upside-down position). But under the leadership of a certain smart young man who had a totally scientific approach to issues of life, an elite group of survivors decided to make their way upwards to the bottom of Poseidon, accurately deducing that water pressure would soon shatter every barrier to deluge the ballroom and drown everyone there.

Those who refused to accept scientific Truth sat around in the ballroom waiting for their miracle. But the chosen few felt the odds of survival were higher if they attempted to move *upwards* to the "bottom". Their logic was that Poseidon would soon be flooded, and the flooding process would leave an air bubble upwards toward the bottom. This could help them hang out longer as they made their way through to the bottom of the ship on to possible rescue.

Every sane person (quite unlike the *Nigerianist*) admits that Nature abhors a vacuum. In this instance, what air bubble could have been

indefinitely entrapped in water in this fashion, before the Law of Nature came knocking to exact its pound of flesh?

The ballroom by now massively under water pressure from outside, all barriers of glass and steel started to give in. It became hugely deluged, which drowned everyone without a single survivor. Only the small elite group making its way to the bottom upwards had any chance of making it out alive to wait in rafts for rescue helicopters, which came not so soon.

This movie experience was not in a fancy theater or large living room with a big screen. I was crawled up in bed, reclined under an old duvet and practically cuddled up with an hp laptop as I watched this spine-chilling story. I suppose such intimate physical "proximity" to the sight and sound of the movie made it hit me with such brutal realism that pounded into me meanings pertaining to all aspects of life. To begin with, it dawned on me with a certain jolt the eeriness by which this movie incident is totally reminiscent of *Nigeria* as I see it.

(i) Soyinka's Nation Space Theory

Nobel Laureate Professor Wole Soyinka graced *The Guardian* newspaper of Wednesday March 4, 2009. This edition of *The Guardian* featured venerable Professor Soyinka's lecture titled *Between Nation Space and Nationhood*. It featured also the article *Soyinka Raises Nationhood Posers at Lecture*.

Consider this from *Between Nation Space and Nationhood* –

> On my part, I have had cause to refer to the entity known as Nigeria as a nation space. It was, for me a convenient way of avoiding pointless debate that would distract attention from whatever concerns I was engaged upon at the time. Quite simply, 'nation space' renders palpable the notion of Nigeria, advances it from mere representation from the printed atlas and places it on terrra firma. We are all occupants of space, so we can jettison all fears that perhaps, in reality, we are a mere figment of the world's imagination. The entire world knows where to find us. When they do find us however, that is, when they explore the contents of that space, probe its interstices and enter both negatives and positives in the ledger sheets of national existence, what do they find? A nation? Or a mere inhabited slab of real estate with no cohering philosophy of reproducing our existence, of harmonizing co-existence, or integrating the constituent parts into a discernible, functioning whole – all of which transform a mere nation space into true nationhood?
>
> The state, despite its impact on civil life, and its agencies – despite its military, police and even the legislature – exists in virtual reality, unlike community or nation, which are palpable entities, and are the productive units of human organization.

This passage serves *proof* that the most intelligent and enlightened individuals among Nigerians, do not see Nigeria as a Nation – *yet*. Beginning with Awolowo's "geographical expression" to Soyinka's "nation space", negation of *Nationhood* is clear for those who admit a lot of work needs to be done.

The most gifted of minds among the Peoples of Niger Area – the types who created Great Nations in other parts of the World – continue from generation to generation, to see a yawning dichotomy between "state" and "community", ascribing "virtual reality" to the former, and "productive units of human organization" to the latter.

A situation in which "state" is only a *virtual reality*, and yet thrusts to diminution the Nativities who are in fact the *productive units of human organization*, thus casts Nationhood to negation.

Consider this also from the article *Soyinka Raises Nationhood Posers at Lecture* –

> He pondered the question: Is Nigeria a nation today? And said: "My answer is: 'Not yet.' Is Nigeria aspiring to be a nation? The answer is: 'Unsure.' Can it? 'Possibly.' Should it? My answer to that is absolutely non-sentimental, purely technical and subjective: I prefer not to have to apply for yet another visa when I need to travel to Enugu or Borno."

With a visa granting *liberty* to travel to Enugu or Borno, our revered Professor would be better at peace than as held in the fatal *captivity* of Poseidon keeled-over in the middle of the sea.

> In a tour of the nations of the world and governments, he said: "Nations do not exist as mere abstractions. A nation is a material implantation, and the building block of that growth is the human entity. The proof of that is both historical and scientific."
>
> He pointed out that elections and constitutions are some of the agents, what he calls "protocols of association" through which a state can become a nation.
>
> "Let no one misunderstand, from the attention we have given to the protocols of existence, that this alone is the route to nationhood. Constitution is only a part of the story.
>
> He recalled that it was Awolowo who first designated Nigeria a mere "geographical expression," a statement, which according to Soyinka "many of our thinking compatriots understood exactly what he meant, and agreed. Others declared that this choice of expression, right or wrong, did give some serious food for thought, constituted a challenge to turn aspiration into reality."
> Others, he said, went into a denial, and asked how "dare this politician diminish the stature of our dear own fatherland, the 'giant of Africa' with such a reductionist phrase!"

> Soyinka stated: "To accept the possibility that the space designated Nigeria had not yet attained nation reality meant hard work, a determination of mind and energy. It implied the exertion of intelligence, the bond of collective desire and the ethics of inclusion. A nation is brought in to being through the political – and inclusive – will of its citizens, not through mere naming."

Our amiable Professor herein observes that the building block for the growth of a nation is the *human* entity. But what do we have in *Nigerianism?* As its pathetic history shows, and sustainedly, Nigeria depends so heavily on detraction – even destruction – of the human entity to be a "nation". A courtesy call to any typical "Nigerian" hospital is all it would take to convince anyone in doubt of the *worthlessness* of the life of a Nigerian. Doctors born in *Nigerianism* and nurses bred in this Existential Pathology have hearts ripped out and are able to add very little to the worth of the life of the Nigerian. Historically speaking also, the punitive expeditions of the Nigerian Army to communities in Nigeria and the wreaked desecration of life have not proved the worth of the human entity as in the status of *Nationhood*.

When the human entity has no Say let alone Way (as in the *Intimidationism* and *Impositionism* of *Nigerianism*) except as "discovered" and ruled by forces of Genocidal *Antagonism*, how does it become the building block of a Nation? Such a "nation" which depends so heavily on the reduction of the humanity of its citizens in order to exist, can only run on borrowed time. *Good* will soon over-run *Evil* such that the forces of coercion as of its *Intimidationist* Artificiality and *Impositionist* Superficiality, will be short of fuels of feudal fraudulence and genocidal violence, only to fizzle out in its totally equitous Cessation.

Ethnic diversity could have been a source of strength to be harnessed for development. But *Nigerianism* has been such that ethnic diversity has been a source of weakness, instability and unviability. Where an ideology of *Nationhood* exists, it is possible to harness ethnic dynamism into the melting pot of its creativism. But in the total

absence of a Nationhood *ideology* as in Nigeria, ethnic diversity establishes as a satanically virulent pathology.

Thus while great Nations typically harness ethnic diversity to synthesize and catalyze greatness, it has only worked in reverse – *upside down!* – with the Nigeria experiment. Why is that so? The answer to that puzzle would suggest negation and Cessation.

(ii) US National Intelligence Council Report

The US National Intelligence Council Report on Sub-Saharan Africa of 2005 caused quite a stir in some quarters when it was first made public. The Captain of *Poseidon* made the same fatal mistake in contending against the good advice that "these things are not built to float upside down". Come to think of it really, what kind of Nigerians would take offense at such a well-intended Report by the US National Intelligence Council, except of course – the *Nigerianist!*

Than argue blindly, one needs reflect intelligently and sincerely, What is the source of such Intelligence? How true? What can be done to avert such a grim portent of "outright collapse" of Nigeria as a nation-state, if any iota of truth is discerned to be in it?

But many a Nigerian ruler and follower alike are not so endowed of spiritual and intellectual subtlety. Their sophistication is rather more comfort in falsehood as of the Nigeria Existence. They simply cannot own up to the fact that no nation can float upright on the Ocean of Life by being predatory toward the true spiritual aspirations of its own citizenry, as well as the humanity of the Nativities.

His blind disputation only tells tales of the negative focus of the *Nigerianist*, who consistently fails to apply creative approaches to issues of the African existence. His negative definition of "sovereignty" artificially props-up *Poseidon* in its distressed condition, wielding the very same *Intimidationism* and *Impositionism* by which Nigeria was "discovered" in the first place!

Real and sincere efforts to attain the status of *Nationhood* at first require cultivation of the appropriate attitudes in approaching problems. The noise that many a Nigerianist made at the release of that Report gave away the shallowness that is only typically Nigerian. To begin with, it is clearly written at the bottom of every page of that 17-page Report: *"Discussion paper – does not represent the views of the US Government."* It is also clearly written on the first page of this same document that it is only a Report on the conference convened "to discuss *likely trends*" in Sub-Saharan Africa. At no point in the 17-page document does it assume dictatoriality and finality, as to present its contents as a militarist truth that must be politically *imposed* upon Nigeria by the *White House*, and militarily *enforced* by the *Pentagon* for it to come true to the letter!

Yet many a *Nigerianist* went overboard in utterances that were inappropriate, almost as if the United States Government had launched a full-scale war on Nigeria to forcibly etch-in "outright collapse" of Nigeria as a US sovereign bias. Such attitudes only serve to divert attention from the *hard work* needed *if* Nigeria will ever qualify for the status of *Nationhood*.

Such negative disputation gives away the fact that attitudinal focus upon *actually* resolving those issues that produce such intelligence reports is still non-existent – as representative of failure of *Nationhood* in the Nigeria experiment. By making so much noise attention is being diverted from the need to urgently embark upon some *real* and sincere hard work to *veer off* the satanic trajectory of *Niggahood*, as onto the true Path of *Nationhood*.

A more intellectually credible appraisal of that Report shows that the Report does not mean Nigerians or Nigeria as a matter of fact, more harm than the *Nigerianist* is accustomed to dehumanizing Nigerians with. A closer look at the entire 17 pages of the Report shows that it is not as nonsensical and as false as the Nigerianist made it seem. The Report on the contrary contains lots of gems of Truth concerning African "nations" which we should learn from. What needs be done is seek in all sincerely to turn a new leaf from

evil ways, than castigate "America" only to wallow in comforts of the sin and failure of Nigeria.

A closer look needs be taken at the NIC Report, with a view to showing that the Report was not an all-out American attack on Nigeria. It contains a legion of poignant points as to how the outside world rightly has the *Nigerianist* and his Nigeria totally figured for what they really are, as against the façade they are wearing, which intelligent observers are not buying. Nigerian rulers and subjects who do not like the image *they* alone have created for Nigeria through years of Goat-Rulership and Sheep-Followership, need to explain to the world what they are actually and sincerely doing to turn a new leaf (as in *Revolution*) beyond empty disputation each time they are confronted with salient truths and hard facts about the failure of Nigeria as in the US NIC Report.

> If African leaders can develop their own vocabularies to explain economic development to their citizens, the likelihood of a political consensus developing in favor of growth will be much higher. If such indigenous perspectives are not adopted, the chances for high growth in most African countries will be extremely limited. There is a profound need to ground globalization in local realities. (page 8)

The wisdom in this NIC Report is uncanny! Almost as if the authors of this Report had read the *Sacred Verses of the Revolution!* This is the exact same opinion that *Prophecy of Democracy* expresses concerning *genuine* and *sincere* efforts at development in Africa. The Holy Prophecy *stresses* the need for *vocabularies* to be developed, which take care of the uniqueness of the African existence and experience. In the noble enterprise of cultivation of the African *Identity* and development of the African *Character*, a *language* which derives from unique African perspectives, facilitates construction of a focused *governance psychology*, alone thus which favors the divine objectives of *cultivation* of the African identity-existence, as well as goals of *development* of the African character-experience.

Chapter Two of *Aspect of Revolution in Nigeria* cites the Holy Scriptures of the Revolution in verses 1 and 3b of Volume 1.*Preface.d*

titled *Language of the Revolution*. Herein favors as imperative, development of a language for addressing the distinctive circumstances of the African existence and experience, as for identity-cultivation and character-development.

Continuing with the uncanny insight of the NIC Report –

> Indeed there is evidence to suggest that hydrocarbons have retarded African development, promoting patronage and misrule by African leaders rather than national development. (Page 3)

> It is unlikely that the major oil producers (Angola, Equatorial Guinea, Nigeria, Sao Tome, Sudan) would have a future significantly different than the ruinous record of petroleum producers to date. (Page 4)

> ... to date, oil producers have had very poor development records and much of the oil revenue that African producers receive has been wasted. (Page 7)

History has shown that only *Humanity* is required to achieve *Nationhood*, and never *Oil*. In the case of Nigeria, history has shown that it will take more than the satanic pride of Nigeria's niggapetrodollars, for the transcendental status of *Nationhood* to be impeccably actualized in the African existence and experience. This would explain why the niggapetrodollars is only going to massively fund the nigga-prodigality of the Civil *Artificiality* of the Nigeria Existence, as well as the Evil *Superficiality* of the Nigeria Experience.

There must be a *Nationhood Psychology* that fuel attitudes of *Cultivationism* and *Developmentalism* in governmental processes. Without a Nationhood Psychology impeccably crystallized in society and polity, all the Oil wells in the world put in the hands of the *Nigerianist*, will be squandered and washed into the drains of his niggaprodigality. This means that – for it to have true physical reality and sustainability – *Nationhood* must be a focused ideal in the mental processes of the "Nigerian" beyond external resources such as Oil.

In verses 44b and 44c of Volume 2.2.6.c titled *Mental Matrix of Nationhood*, the Holy Scriptures of the Revolution puts it thus –

> 44b The *Nationhood*Craft thus must derive the *Authoritative*Predication of *Physical*Experience upon its *Authentic*Premise of *Mental*Existence.
>
> 44c It becomes thus only logical that the *Nationhood*Craft must at first be *Authentically*Cultivated in *Mental*Purity, as thus predicates and validates *Authoritatively*Developed in *Physical*Originality.

What a shame that the *Nigerianist* has devised that only his satanic niggapetrodollars equals *Nationhood!* He thus hinges the totality of his definition of *Nationhood* on *Oil,* but remains nigga-oblivious of the fact that *Sovereignty* and *Nationhood* as a function of niggapetrodollars, leaves nothing to fill out the nigggahood-vacuum in the event of evaporation of its niggasophisticationism – except *Cessation!*

> ... a few states have consolidated a sense of national identity while others have been fractured by civil war (Page 3)
>
> ... states with high levels of violence will not automatically become failed states; indeed, the ability of African countries to continue to muddle along despite high levels of violence should not be underestimated. For instance, 20,000 people have been killed in Nigeria while that country has maintained its democratic facad. (Page 11)

Destruction of the sleepy village of Odi after so much celebration of what was deemed a brave return to Democratic values, remains reminiscent of the "fractured" – and deluded – nature of Nigeria's "national identity". If Nigeria had actually attained any such status as *Nationhood* – and especially in a *Democracy* – it would have been a lot easier to evoke the ideals of such *Nationhood,* as well as apply its full *Sovereign* Power, to fish out the killers of a handful of policemen. Such discretion would have served the ideal of *Nationhood Democracy* better than the ordeal of *Niggahood Savagery* which levels out a village in its satanic nigga-superpowerism.

Richard Igiri

The attempt to fathom tragedies such as Odi in the light of *Democracy* – or *Nationhood* as a matter of fact – takes us back to the roots of Nigerian militarism in *Colonialism*. The inherent and perpetuated Civil *Error* of the Nigeria Existence is a function of the *Colonial Mentality*, which wallows the *Nigerianist* in his mental derangement, a total nigga-psychopath! This tragic niggapsychopathy manifests in the Nigerianist when in leadership (rulership) position. It becomes that of his affliction with grandeur-delusions as of an unchallenged and unchallengeable successor to the *Colonial Master*. Thus he must exercise and maintain his authority over his conquered subjects at all costs as in organizing punitive military expeditions to the hinterlands where restive natives dare to challenge his authority as Nigga*Conqueror*.

It cannot be over-stressed that each deployment of the Nigerian Army in any *Nigerian* community in full war-mode, be it in the South or in the North, begs to remind us of what malicious Civil *Error* lies constituted in the Nigeria Existence. This lies especially thus as in the context of *Democracy*. It was the *Colonial* Master who instituted its atrocious Evil *Terror* in the satanical process of "discovery" of the Pathological Existence he called "Nigeria". The *Niggacolonial* Imposter simply imitates the *Colonial* Master. The institutionalized *Error-Terror* of the Nigeria Existence remains a demonical function of the *Colonial* Mentality, whose political complexes and military reflexes harbor the inclination that Nigerians must continue to fraudulently prop-up this corrupt-evil *Relic of Colonialism* through *Malicious* Political Fraudulence and *Atrocious* Military Violence as perpetrated against themselves as such "Nigerians".

The naked Truth is that this pattern of Civil*Error*-Evil*Terror* will never produce *Nationhood*, except perpetuate *Niggahood*. Only attitudes of *Dialog* and *Debate* as onto resolution of issues of the Nigeria Existence can be said to be totally conformatory to the spiritual ethics, as well as the cultural esthetics, of *Democracy*. Genocidal posturing and deployment of soldiers which is the pathetic fashion in *Nigerianism* only proves that Nigeria is a condition of self-embattlement in the African existence and experience: a condition of being at war with one's own self. The Authoritarian *Colonial* in

its Civil *Error*, as well as the Totalitarian *Niggacolonial* by its Evil *Terror*, remain approaches to "national" crises that are massively flawed.

The *Nigerianist* who postures against attitudes of *Dialog* and *Debate* is a fraudster who is afraid that the *Truth* of the Nigeria Existence will come out of its captivity-obscurity. He prefers to wallow in the *Lie* of Nigeria – Fraud of the *Pseudotopia!* In this comfort zone of *Nigerianism*, the *Nigerianist* perpetuatedly wallows in the *Niggahood* of quick-routes and short-cuts to "nationhood", which he must pursue through Fraudulent Civil *Error* and Violent Evil *Terror!*

This satanical process and its atrocious criminality of course only compound *Niggahood*, leading nowhere near *Nationhood!*

In the historical (and *Indigenous*) perspective, Nigerian militarism remains *satanic* in nature and character. This is not to sound condemnatory, but to stress that militarism must be defined in total deference to unconditioned and unconditional *Democracy* as in the *Sacred Verses of the Revolution*. Sacrosanct *Democracy* otherwise remains alien to Nigeria if satanic militarism still lurks in governance *psychopathy*, making fashionable where they become restive, such colonial jihads against Nigerian Nativities in the exact same manner the *Colonial Master* did.

Revolution requests impeccable *Democratization of Militarism* in Niger Area. The satanic scheme otherwise seeking to keep the Nativities living in fear as "discovered" against their true spiritual *Aspiration* for the status of *Self* Discovery *beyond the bar* of "Nigeria", cannot be sustained. Nigeria can never achieve *Nationhood* through genocidal posturing of the Army against any "village", this being without regard to the "unimportance" of such Nativities by the niggasuperpowerists' supposition.

A certain gentleman serving in Government at the time was said to have visited the scene of the devastation of Odi. The comment he reportedly made was, "This country is *finished!*"

This spontaneous anticlimax captures the fleeing of all voluntary allegiance to a predatory State. It tells of negation of psychological realism for a "nation" that imposes itself on humanity only through violence and savagery. A hollow "nation" where "leaders" are only "there" in nigga-acquisitionism – which vandalizes the system such that the Evil Day will surely crown that satanic trajectory in its portent of hollow-out Cessation. It will otherwise take total inclusivism and ethical integrity in Leadership beyond a *mutiny-made* Unity and its *savagery-sealed* Sovereignty to imprint immortal *Nationhood* in the hearts and minds of men!

Thus the Odi massacre is symbolic of destruction of Nigerian Peoples at the Indigenous-community level. But this is just where the seed of *Nationhood* – if it exists at all – should have been sown in love and nurtured with care to imbue it with psychological realism and mental reality in its citizenry.

The *Nigerianist* may like or dislike this, but the NIC Report represents the opinions of experts in international affairs; those who are not so inconsequential as to be positioned to influence policies of major world players toward Africa – or Nigeria. This means that pseudo-intellectual posturing against scientific facts falls far short of the heroism required to metamorphose Nigeria – if that were possible – into pristine *Nationhood*. Once Truth, equity and good conscience – as of *Sacrosanct Democracy* – cannot become cultural status-quo of the Nigeria Existence, "outright collapse" would not be totally out of the question as an accurate prediction of the future of Nigeria. This owes to the fact that the prevailing *New* World Order would no longer be totally supportive of the "sovereign" niggasophisticationism of such a (borrowing designation from the *Sacred Verses of the Revolution*) "*Satanical Travesty of Democracy*".

The Report has Upside Surprises, which include –

Aspect of Revolution in Nigeria

> If Angola, Nigeria and Sudan ... actually design to use their revenues from oil in productive ways, these states would become stronger. ... Better hydrocarbon management might come about because of international pressure to promote the transparency of resource flows, aided by domestic constituencies who have grown tired of the fraud associated with wasting assets.

The Report equally explores Downside Risks –

> The most important would be the outright collapse of Nigeria. While currently Nigeria's leaders are locked in a bad marriage that all dislike but dare not leave, there are possibilities that could disrupt the precarious equilibrium in Abuja. The most important would be a junior officer coup that could destabilize the country to the extent that open warfare breaks out in many places in a sustained manner. ... If millions were to flee a collapsed Nigeria, the surrounding countries, up to and including Ghana, would be destabilized. Further, a failed Nigeria probably could not be reconstituted for many years if ever – and not without massive international assistance.

The NIC Report being highly regarded in my reckoning for the rare truths that it explores, I would however beg to disagree with certain exact *words* as found in the NIC Report or elsewhere. No scenarios will play out in Nigeria such as "... a junior officer coup that could destabilize the country to the extent that open warfare breaks out in many places in a sustained manner. ... If millions were to flee a collapsed Nigeria ..."

That particular projection is stereotyped, and does not take into cognizance the fact that Nigeria has been there before and thus exceeded that level in its social development, even as at 2005. The Holy Prophecy and the NIC Report are divergent upon the manner of it, but totally convergent upon the *Cessation* portent all the same. The NIC Report inclines to *Degenerative* Collapse of Nigeria, while the Holy Prophecy orients to *Regenerative* Cessation of Nigeria. The Report suggests "cataclysmic collapse" of Nigeria, which would inflict wounds upon populaces and the environment that may never

be healed. The *Holy Prophecy* remains distanced from any such interpretation of the crises of the Nigeria Existence.

The *Holy Scriptures of the Revolution* thus rather inspires *Self Discovery* of the African Identity, and thus conspires *Peaceable Creative Dissolution* of Nigeria for *Cultivation* of the African Identity Existence; as well as its *Civilized Constructive Liquidation* for *Development* of the African Character Experience, as onto Transcendental *Nationhood*.

We cannot say that only the US National Intelligence Council can peer into its intelligence crystal balls to tell the future of Nigeria with total divine accuracy. But we must be reminded of the fact that what neighbors say about a person holds some truth about that person. The image that one "nation" cuts to the outside world among other Nations of the World also holds truths about the status of such a "nation". Thus if individuals within and without, divinely gifted with insight into life see Nigeria as prone to "outright collapse" – and nothing is being done, or indeed can ever be done to evacuate Nigeria from that *institutionalized devilish trajectory* – this is a huge portent of ultimate *Cessation!*

If x is not 1, it can only be – a big – 0. Thus if *Nationhood* is totally negated as in the *Nigeria* experiment, only the evil abysm of *Niggahood* graces the vacuum.

If Poseidon is not floating impeccably *upright* on the Sea of Life, it can only be floating distressed *upside-down*. But for how long before the entrapped air bubble (its *niggapetrodollars*, armed-thieved from demolished Nativities!) fizzles out and it takes the final dive for the bottom of the sea in its totally equitous *Cessation?*

(iii) $(Ni - Oi) = 0$

How do we begin to appraise this weird algebraic equation, as to arrive at any semblance of its solution?

Well, let us begin the traditional way – by removing the brackets! Let us say that the value *Ni* inside the bracket is an algebraic symbol for *Nigeria*, while the *Oi* is the algebraic representation of *Oil*. This weird algebraic equation with brackets removed thus to demystify it and subject it to solubility, goes something like this: *Nigeria*-minus-*Oil*-equals-*Zero!*

To put it more graphically, Nigeria minus *niggapetrodollars* equals *Big Zero!*

This would suggest that the totality of the "sovereign" niggasophisticationism of Nigeria is pathological dependence on *Oil!* The struggle for the existence of Nigeria is upon Oil exploitation interests, which holds in *feudal disdain* spiritual concepts of the *dignity of man,* while casts to utter *genocidal contempt* cultural precepts of the *sanctity of life* as onto the pristine *Nationhood* status for the African Identity.

What an irony that pristine *Nationhood* lies in the *opposite* direction! *Oil* Discovery produced corrupt Satanical *Niggahood* in the African theater of experience: only *Self* Discovery creates pristine Transcendental *Nationhood* in the African sphere of existence!

Self Discovery of the African Identity is a surer foundation for the *Nationhood* status than material resource of the fields such as *Oil*. A nation otherwise which came into its *Impositionist* existence through *Intimidationist* "discovery" of the Nativities and continues to exist on such satanic premises and its demonical authority, cuddles the portent of *Cessation* in an existential scenario which transcends *Self* Discovery and its divine individualism to *Oil* Discovery and its demonical niggapetrodollarism.

The looming possibility of a scenario in which Oil no longer flows so abundantly sympathizes with a Cessation portent for Nigeria. The truth is that takings these decades of abundant Oil flow have not been well deployed, owing to maniacal and genocidal lootings of outlandish proportions by the very same *Nigerianist* who comes back to tell subdued Nigerians they have no other "nation" to call their

own. The *Nigerianist* proclaims Nigeria a God-Country with unity and sovereignty that must remain sacrosanct, yet he would *Shoot* such Unity in *Feudal* Sin, and *Loot* its Sovereignty through *Genocidal* Savagery. Who is being fooled here? Diminished *Nigerians* of course, "nation" of fools!

Worse still, as a result of the massive hauls of niggapetrodollars into foreign vaults by "leaders" of Nigeria, the environment and Nativities will have nothing to show for being Oil-producing, except environmental degradation and cultural devastation. A satanical scenario of existence in which revenue accruing from Oil is not being *massively* plowed right back into healing the land and developing the Nativities but nigga-prodigally squandered, spells negation of *Nationhood*.

A situation in which as much as 80% of Oil revenue (according to experts) is not being used to *develop* Nationhood values, but squandered in funding the nigga-prodigality of underproductive governance bureaucracies, which are distanced from the *humanity* of the Nativities, does not exactly bode immortality for Nigeria as the Nigerianist would have the world believe.

Consider Nigeria as a "business" which is fledgling on a *loan*. (That is what the Oil Money actually is, since "Nigeria" did not *create* or *generate* it – neither does Nigeria actually create or generate anything to develop the *worth* of the human person!) If 80% of that loan is used to "pay" the infantile and infertile fantasies of underperforming-fraudulent staff and impostor-contractors, how does such nigga-squandermania guarantee business prosperity – immortality for Nigeria?

The maniacal niggapetrodollar vanity of Nigeria has fallen such that its *Legislootership* is said to be paid better than President of the United States in a "nation" of deprived Nativities and citizenry. When a bank loan secured for a project is being "chopped" as if it were in fact profit, what future has such a project? The *niggaprodigality* of Nigeria is such that as a "business" it has not made any profit in all the pathetical decades of its pathological existence, yet the

Aspect of Revolution in Nigeria

Nigerianist is "chopping" niggapetrodollars as if it were indeed and actually profit *generated* by Nigeria. It takes an idiot "nation" to plunder and squander *Principal* before it has ever learned to invest wisely and yield *Interest!*

What a *niggasovereign* opprobrium!

If the honorable members of Nigeria's *Legislootership* receive higher "pay" than President of the United States, what Law of Economics would make such a violation of proportions workable to guarantee sustainability and a "bright future" for Nigeria? Do not these institutions – USA and Nigeria – operate within the realities of the same world economy? Thus only the "laws of economics" as invented by the *Nigerianist* supports nigga-ostentation and living beyond one's means as the quickest route to a "bright future"!

A German gentleman was once quoted as having said that Nigeria would have been a much better place if the Oil wells were all capped. What a paradox! But this observation has no poetical connotation, and remains a prosaic denotation of the naked *Truth!* Oil made the Nigerianist a typical Lazyman, always cutting corners to avoid the hard work needed for construction of the *Nationhood Craft* (again if we may borrow that from the *Sacred Verses*)!

Nigeria is a typical "resource curse" situation. This designation – *resource curse* – depicts a satanic scenario of existence and experience, in which Oil became a curse to the People instead of a blessing. This "paradox of plenty" – and paradoxically – creates more underdevelopment and less development by virtue of enriching satanic Cartels and demonic governmental Cliques while wreaking degradation upon the populaces as well as devastation of their Native lands. The nigga-sovereign existence of a *Resource Curse* such as Nigeria is a function of *failure* of attainment – and thus *negation* – of the status of *Nationhood!*

Nigeria is only nominally a "nation" thus, and one of uncreative and underproductive sluggard-leaders in the scramble for the infantile fantasies of its satanic *niggapetrodollarism!* The story of palm kernel

seedlings smuggled out of Nigeria, which transformed Malaysia through *directionality and hard work*, is a case in point proving that Nigeria is an infected, stagnant pool of water: *nothing new ever comes in and nothing old ever gets out!*

What was Nigeria doing those years of hard work that transformed Malaysia with seedlings borrowed from her land?

The answer is that Nigeria wallowed in *non-definition of identity* and its *purposelessness,* thus swallowed in *negation* of *Nationhood – locked intractably hard in its Cessation portent!*

If the whole truth were to be boldly told, Nigeria is not *developing*. The huge strides being made by progressive *Nations* of the world as seen on TV is only being "splashed onto" Nigeria. This is what creates the *illusion* of progress in Nigeria. Add up the minuses and pluses of the Nigeria Existence, and be appalled the notion that Nigeria is *developing* or making progress is a huge *illusion*. The situation is more like *One Step Forward, Two Steps Backwards* – on the satanic superhighway to the ultimate Nigerian Dream!

Foreign investment into Nigeria does not in itself constitute progress and development for the African *Identity* as in the holistic sense onto *Nationhood*. Dependence on foreign investment is like asking to be re-colonized – making Nigeria nothing but a market colony of such investing powers. According to the Holy Scriptures of the Revolution, there must be *Cultivation of Identity* in order that *Development of Character* may become totally regenerative.

This is not to say that foreign investment is unimportant, but simply to say that the African *Identity* must be *Cultivated* into Nationhood, for *Development* of Character to fit-in into progressiveness in the holistic sense. Foreign investment falls into the category of *Development of Character*, but in isolation makes *Nigeria* only a market colony as of *Recolonization* of the African Identity.

Therefore "Cultivation of Identity" is the missing ingredient of *Nationhood* in the Nigeria experiment. The *directionality* and

purpose in *Cultivationism* (borrowing that concept from the Sacred Verses of the Revolution) is the difference between a *developing* or *developed* Nation, and a *stagnating* and *underdeveloping* Country. It is the difference between Malaysia and Nigeria.

Again, for how long can Poseidon float *upside-down* in the middle of the sea before the Laws of Physics come knocking to exact their pound of flesh and send it to the bottom of the ocean where its satanic niggapetrodollar pride has prepared its permanent abode?

(iv) Facebook Post

> A lady has been jailed for 7 years for stealing a car. (Name herein withheld) was jailed for 18 months for stealing N2.8b, enough to buy 2,800 pieces of the same car. (Name herein withheld) was jailed for 6 months for stealing N54b, enough to buy 58,000 of the same car.

The foregoing is a March 9, 2011 Facebook post by a gentleman who is bemoaning Nigeria. A situation in which what constitutes a crime is not even well-defined for public office holders, denotes total subversion of the status of *Nationhood*. And when it would appear as if Nationhood is actually in place, Lawlessness overwhelms the Law such that one citizen who commits a mind-boggling crime against the "nation" is given honors due the wizard for being smarter than other Nigerians. Yet another citizen who commits misdemeanor against their neighbor is punished with a "sovereign" vengeance. Such an existential pathology institutes the *Cessation* portent for an Anarchy State where "successful" lawlessness and niggasovereign criminality are accorded heroism.

The true status of *Nationhood* is one in which law and order is well-established such that *Nigerianism* as recounted above would be impossible. A situation in which one person is jailed seven years for stealing one car, and another is jailed six months for stealing 58,000 cars, institutes "nationhood" on the demonical quagmire of *Niggahood* hard-locked in its intractable *Cessation* portent!

A huge *Cessation* portent looms over such a pathological existence since Nature rejects the vacuum of Satanical *Niggahood* seeking usurp Transcendental *Nationhood!*

In Volume 1.3.2 titled *Termite Attack*, the Holy Scriptures of the Revolution likens Nigeria to a loaf of bread *hollowed*-out by ferocious "termites". Thus what we have as "Nigeria" is nothing but the *outermost crust* of a loaf of bread as ferociously and satanically hollowed-out of all integrity and barely hanging-on by a delicate façade-fraud.

The maniacal fraudulence of this *Failure State* has been such that each time huge Government funds are chopped-off and carted-away, a furor is usually *enacted*, which quickly *fizzles-off* – and the thieves can keep the loot anyway. They walk off unapproachable, deified in Nigerianism. Does not the ethos of Nigerianism thus satanically configured prove that Nigeria is an *Integrity Failure of Niggahood* that will never attain the existential status of the *Integrity of Nationhood?* Thus who is the foolish *Nigerianist* wallowing in the illusion that he possesses cunning to perpetuate deceit upon the whole world with ascription of "nationhood" to blatant *Niggahood?*

Let us attempt to mention one *Real* Nation in the world where public servants blatantly perpetrate economic, political and military crimes of *Nigerianocentric* magnitudes against the People, only to be deified. What an uphill task this would be! Do not these *Real* Nations (such as inspire the African Identity onto its own status of *Nationhood*) predicate their existence on advanced systems of law and order that make it impossible for individuals or groups within their citizenry to flout their credibility and desecrate their integrity as such *Real* Nations with *Nigerianocentric* impunity?

The failure of credibility and integrity as of *Nationhood* in the Nigeria experiment, as well as flagrant-pervasive and blatant-prevalent lawlessness within governmental cliques, hinges on the fact that Nigeria itself *was not established on any advanced system of law and order*. Was not Nigeria established through forms of invasion-impositionism? Is it not continuing to self-exist as a "Law

Aspect of Revolution in Nigeria

of Impositionism" in negation of any advanced system of Law and Order (designed and designated *of, for* and *by the People* themselves), which is binding enough to contain the demonic penchant of public officers to heap insult on the "nation" and wreak abuse of genocidal proportions on the citizenry – and with satanic impunity – only to walk off scot-free, heroes and demi-gods of the Nigeria "nation"?

Against this pathetic credibility-flop and integrity-failure as a *Nation*, would it be so out of place to visualize outright *erasure* of this Mistake ("Civil *Error*" in the phraseology of the Sacred Verses)? A crafty draftsman, who makes a mistake during the pencil work of what would become an important structural drawing, *admits* an error has occurred. He first *stops* in all professional honor and integrity, and *admits* a mistake has been made. He does not pile up on the mistake (as in *Nigerianism*), but must in all professional discipline *erase* the mistake ever before he can proceed to create a true structural masterpiece.

Would not *erasure* of the Mistake called Nigeria liberate the Peoples onto Civil *Liberty*, such that they may borrow a divine leaf from those *Real* Nations who proudly boast Credibility and Integrity as of *Nationhood;* start from scratch on advanced systems of Law and Order as in *Democracy* (which eludes Nigeria), onto Nations of *New Age* Africa as in the *Holy Prophecy?*

Tolerance of this *Termite-Attack* nigga-civilization otherwise invites nothing but institutionalization of the opprobrium of a "nation" without integrity – or violated and hollowed-out of integrity and credibility if it ever boasted such virtues. But for how long can our *Hollowed-out Crust* hang-on, a mere farce of a loaf and the fraud thereof, before it caves-in in vindication of the Law which states that Nature abhors a vacuum?

Beyond societal law and order, and by extension onto the existential context, *Nigerianism* is an existential tragedy in which the Villain in Cultured Society is called Hero, while the Hero of Cultured Society is called Villain. A satanic nigga-civilization which accords Heroism to Villainy, and discords Villainy with Heroism, is not Civil *Nationhood*,

but Evil *Niggahood*. Nigeria has it all twisted, turned topsy-turvy – floating *upside down!*

For how long can *Poseidon* float upside down, before the Laws of Physics catch up with it sending it permanently and eternally down to the bottom of the ocean?

How long can Nigeria honor the Villain with Heroism and dishonor the Hero with Villainy, before the *Law of Life* closes in on it with *Cessation?*

In Volume 2.3.4.e titled *Woe Niggatopia*, the Sacred Verses of the Revolution rails at the *Iniquity of Man* thus –

> 4 Niggatopia! Niggatopia! Niggatopia!
> Thou Evil*Sorcery* who parades vile villains in splendors
> While great heroes grave-anguished languish indoors!
>
> 5 Niggatopia! Niggatopia! Niggatopia!
> Thou *Niggahood*Dystopia who fetters brave erudites in squalor
> While thy spineless imbeciles roam unfettered in valor!

In the poem *Iniquity of Man* (Volume 1.3.7), the Sacred Verses of the Revolution rebukes Nigeria as a *"Den of Discord ... where foul is fair, ... villain valiant." "Broken bottles litter kids' pen"* graphically illustrates the most outlandish social outrage and existential contradiction, which continues to pass daily, institutionalized as the "sovereignty" of a nation. One only has to take a peek at the pages of the dailies, to be appalled by institutionalized violation of humanity behind the scenes passing daily as the unity and sovereignty of Nigeria.

This is of course not intended to be condemnatory, but only by way of telling the Truth as if standing at the mirror in sincere self-appraisal. Does the Nigerian like the image in the mirror? If not, what is he *doing* about it? It would appear the satanic process of his "discovery" configured personality of the Nigerian in negativism and defeatism such as *disables* him to do anything about his existential

contradiction as the Nigerian – except complain. He can only wait hoping – for Poseidon to take the final plunge for the bottom of the sea!

Nigerian intellectuals have observed that each governmental administration succeeding is worse than the preceding one. "Blame the *discovered* system, not the helmsman!" I would always retort. This trend – in which governance is *declining* esthetically while government is *degenerating* ethically – suggests not a Peak of civilization in the future of Nigeria: it rather bodes a fatal-crash at the Abyss of its barbarism, futility and failure! Typically unchecked in *Nigerianism,* this nigga-phenomenon lies as a terminal ailment in man. The toxicity of its energy bodes not immortality as the vain Nigerianist would have us subscribe to: it logically bodes terminality as in its portent of *Cessation!*

(v) Dreams and Visions of Saints

The *dreams and visions of saints* is yet a divine-dimension index of the *Cessation* of Nigeria. These sacred dreams and visions sent from the very *Throne of the Almighty* to his Saints in Nigeria, are *not* dreams of *cataclysmic collapse* of Nigeria. They are spiritual dreams of *peaceful, creative* Dissolution, as well as of *civilized, constructive* Liquidation of Nigeria – by Supreme Being Himself, and for holy purposes of identity-*cultivation* and character-*development* only.

A gentleman was once invited for worship at one of those "power-packed" Pentecostal Churches, full of the out-pouring of the Holy Spirit. When it was time for the in-house Prophetess to speak, she was already in her usual spiritual trance, out of which she gave out messages on every manner of mortal concern as the Holy Spirit gave utterance to her.

Sister Esther, as we will call her, went into *lamentation* over Nigeria. This had become a "nation" whose satanic niggapetrodollar pride stands-against all of the Plans that Supreme Being has to better

the lives of His People. As a result of these great evils – which predominate Nigeria for its Feudal Unity, dominating the Nativities by its Genocidal Sovereignty – as satanically perpetrated by the Heathen, the Lord had decided what to do to liberate His People and rid them of the bondage of the Egyptians, bringing them onto a Land flowing with milk and honey.

The summary of the prophecy Sister Esther pronounced to the entire congregation that afternoon was that the Lord of Hosts had decided He alone, and by His Very Own Holy Hands, will split Nigeria clear into *three* distinct Nations.

The entire congregation did not unusually stand still, because they had heard it all before. Some have even heard it straight and direct from the Lord of Hosts Himself, revealed to them in their own dreams and intuitive awakenings. Of course the worship session proceeded quite normally, it was no great "breaking news" from the Lord of Hosts!

In my own small way, I have also had mild glimpses of these *Dreams and Visions of Saints*, which unambiguously index, as well as unequivocally portend, the *Cessation* of Nigeria.

In one of these sacred dreams, I was watching a news program. It could have been on *CNN* or on Nigeria's national television, the *NTA*. But it was a very significant news event. The title of the report was "Creation of New States". The report was showing a map of Nigeria with delineation of the *New States* just created. The report was of a happy event, which put smiles on the faces of *the People*. It was not a sad report of war and bloodshed, but one of elation and jubilation as of peaceable and civilized processes of *Democracy*.

I woke up from this dream totally aware of what the Lord and Maker of the Universe was saying. This sacred dream was not about "states creation" as we know it *within* the Subversion-of-Destiny called Nigeria. The "new states" that were just created as Heavenly Father showed in this dream were *not* "Nigerian" states.

Aspect of Revolution in Nigeria

The borders that were shown in that dream were not *national* borders as of states *within* Nigeria. These were *international* borders of Nation-States *beyond* the feudal inequity and *outside* the genocidal iniquity of Nigeria. These were the *New* States spoken of in the *Holy Scriptures of the Revolution*, such as the Republic of *Arewa*, the Republic of *Biafra*, and the Republic of *Oduduwa!*

The theme of this sacred dream was "Creation" of *New* Life, and not even "Destruction" of the *Old* Existence. The event was as elating and elevating as the birth of a King, as opposed to distressing and depressing as the tragic death of a compatriot. It was one of the joy of noble expectations met, as well as of the ecstasy of spiritual dreams fulfilled. The entire dream episode stood to prove that with the *Hand of God* in it, these African Nativities have nothing to lose but everything in the world to gain in the (*peaceable* Dissolution and *constructive* Liquidation) *regenerative Cessation* of Nigeria!

The saints in Nigeria and outside have seen these dreams in so many different ways. The spiritual history of Mankind will show that Supreme Being usually reveals it to His Saints when He moves to create something of such great significance for their benefit. It is upon the spiritual strength of the *Dream of Saints* that I am personally convinced that the Hand of God is in the portent of the *Cessation* of Nigeria. And if the Hand of God is in it, it cannot be but for Good, and never for Evil, since He is the Holy One always thinking for His children thoughts of good and never of evil, but onto an expected end – of *Cultivation* and *Development*.

The prophesied *regenerative* Cessation of Nigeria will break forth with a *Natural Force* similar to that of a tornado or a tsunami, toppling every strong-head *Nigerianocentric* negativism in its divine Path. It cannot be made manifest by the hands of man, which knows only to *destroy*. Providence alone is able to *create* in the holistic sense of it.

Consider this Divine Prophecy thus: if the US Army, the Russian Army, the Chinese Army, the French, German and British Armies were to *converge* brain and *merge* brawn in an invasion

of Niger Area to establish these Indigenous Nations of *New Age* Africa, what *Nigerianocentric* "power" can resist such a *Divine Intervention?*

Consider thus a hypothetical scenario in which Mother Britain herself were to *invade* Niger Area militarily, to *enforce* the *Regenerative* break-up of Nigeria in such a *Divine Fiat* responding to the divine *Aspiration* of its *Captive* Nativities, which establishes the *Arewa* Republic, the *Biafra* Republic and the *Oduduwa* Republic. Would not such a *Revolution* be enforced with the very same *Sovereign Power* she used to establish the *Bad Marriage* in the first place, which the *Nigerianist* claims "can never" be broken to liberate its *inmates?* If God's Intervention could take such a fantasy turn in Niger Area, what Niggahood Power can resist such a *Natural Force* divinely purposed by its *Spiritual Authority?*

For it to be *worth* it, *Revolution* must come about in Niger Area by spiritual power and authority of *that* magnitude such as dwarfs into *inconsequence and total defeat,* all *Nigerianocentric* negativism and antagonism. Revolution wouldn't be worth it thus were it just a shift from one phase to another of the very same pattern of "African" negativism, corruption and failure. The mission of Revolution as in the Sacred Verses thus is *total evacuation* of the African Identity and Character from that satanic trajectory of the African existence and experience as devilishly constituted in "Nigeria", without such Divine Rescue which assuredly terminates tragically – as *Poseidon* did.

The Dreams of Saints show that a *Divine Intervention* of that *magnitude* is lurking just around the corner. That *Help From Heaven* would not come if the People had not asked for it. But they did and it will come. What precise form it takes cannot be accurately figured by the mortal mind of man. It surely will come by that magnitude of spiritual power and natural force as of an international political and military coalition in its favor, such that nothing *Nigerianocentric* can stand in competition with it or in contention against it.

Only such *Divine Power* and its *Natural Force* can leverage a depressed existence and suppressed experience as in total evacuation of the African Identity and Character from the Satanical *Captivity of Niggahood* in Nigeria, onto the Transcendental *Liberty of Nationhood* in *Indigenous Nations of New Age* Africa such as the *Arewa* Republic, the *Biafra* Republic and the *Oduduwa* Republic, as in the *Holy Prophecy.*

Conclusion
DON'T GET IT TWISTED!

a. Symbolism of the Sacred Verses

Going by the Divine Psychology in the Sacred Verses, *Revolution* in Nigeria dons the aspect of intellectualism, which lies resident in non-secularism. Thus no street-corner clamor or city-square protest serves so remotely sympathetic to the divine object of *Revolution* in the Nigeria context.

Revolution in Nigeria thus must begin with an *intellectual awakening*, which boldly challenges – and humbly calls to question – the satanic fraud of Nigeria's total-fraudulent claim to the existential status of *Nationhood*.

The existential and social malaises which daily terrorize the *Nigerian* and eternally haunt his existence, owe to the fact that the *Nigerian* is a character who continues to have the very same malaises shoved down his throat as a certain "nation". Of course he swallows it all, only begrudged and grumbling – short of enabled, let alone empowered, to do anything about it. How on earth can he? Is he not *Nigerian?* Of course he is only *Nigerian* as "discovered" into emasculationism and diminutionism for that same purpose: to have the nonsensicality of Satanical *Niggahood* shoved down his throat for Transcendental *Nationhood!*

It would take a spiritual and intellectual *Revolution,* which cultivates a psychological orientation *superior* and *alien* to the *Nigerianocentric* to achieve salvation of the *Nigerian*. This would suggest a *change of consciousness* in the Nigerian, such as constructs a personality-type *higher* and *superior* to the *Nigerian* as "discovered" and designed to be stripped of humanity in Nigeria's Feudal Political Unity, and trampled upon with its Genocidal Military Sovereignty.

The aspect of Revolution in Nigeria could encapsulate thus: *"Be ye transformed by the renewing of your mind"*. It could further be totally resident in: *"Resist the Devil and he will flee from you!"* The *Nigerianist* remains the imbecile-demon who has failed to articulate any definition of *Nationhood* with intellectual integrity superior to being "discovered" through Conquest and Colonization. The *Nigerian* needs flee from this lone Satanic Agent!

Revolution thus must challenge the *Nigerianist* to an intellectual *Debate*, which would task him to prove to the whole world that Nigeria is a *Nation* – like France, Britain, Israel, USA, India, Japan, China or even South Africa. This divine process of exposure of the spiritual hollowness of the *Nigerianist,* as well as the ideological bankruptcy of *Nigerianism* – which task him to *Debate* Nationhood than *Dictate* Niggahood – in itself constitutes *Revolution!*

In its symbolism thus, the *Sacred Verses* celebrates that *intellectual awakening* and *transformation of consciousness* (the *renewing of the mind*) among the *Indigenous* Peoples of Niger Area. It symbolizes evacuation of the *Indigenous African Identity* from the suppressionism of his psychological degradation in the *Colonial Mentality* of being "discovered" into his existential diminutionism as the *Nigerian*. Revolution resides thus onto elevation of the African Identity to a *Nationhood* Psychology alien and transcendental to *Nigeria* as a pathological existence of ideal-subversionism in nigga-idiocy.

Among the Peoples of Nigeria, many daily "pray" for *Divine Intervention* in the affairs of Nigeria. Supreme Being usually does respond to supplication or visualization. But in the human-level consciousness man may not be apt to discern it when and how His response comes.

The *Holy Scriptures of the Revolution* quite easily represents *Divine Response* to the fervent Prayers that the Peoples of Niger Area daily offer to Supreme Being to be shown the Way Out of the *Ditch of Dystopia,* which lies constituted in *Nigeria*.

The divinity of Godhead necessitates renunciation, which means that the Absolute can only send an Answer of a spiritual nature. The spiritual nature of God's Answer means that it is "neutral" somewhat: Supreme Being grants man the *choice* to accept *or* reject His Divine Answer to problems of his existence and distresses of experience.

The *Awakened* African Identity of the *New Age* thus wields a mental focus of spiritual sensitivity such as welcomes *Divine Remedy* for the existential pathology called Nigeria, as Supreme Being has analyzed and given it in the Holy Prophecy.

In total divine conformity to the nature of *Democracy*, the *Holy Scriptures of the Revolution* is presented as a *Debate*, not as a *Dictate*. The Power of the Gun *Dictates* in Autocracy, but the Power of God *Debates* in Democracy. Thus in spite of its total-incontrovertible Divinity, the *Holy Prophecy* does not constitute a Divine *Imposition*, but a Divine *Proposition,* which grants us *Choice* as to accept *or* reject.

Also, that this *Holy Book of the Revolution* is not an import of any kind, but a hundred percent locally made, serves proof that the *Indigenous* Peoples of Niger Area have come of age spiritually, as to be able to create such a vision of the African IdentityExistence and CharacterExperience. It symbolizes that African Peoples of the Niger Area have come to such a status of spiritual maturity in which they are able to spiritually take charge of their Destiny as into their own hands to create an existential status of *Nationhood* through impeccable *Self* Discovery as in the *Sacred Verses of the Revolution*.

The *Sacred Verses* is a "Blueprint" for the *God of Democracy* to work with. Such a Blueprint must be a spiritual document written *by* the People, *of* the People, and *for* the People, being as constituting a spiritual document of *Self*Portrait. Such a spiritual document of *Self*Discovery is as a tale of *Self*Portrait, which grants the *God of Democracy* express permission to intervene and help the People "act it out" as it were.

The *Sacred Verses* thus symbolizes the disciplic discipline of *writing down a dream on paper*, which is required by *Supreme Being* in the divine process of its *manifestation!*

The *God of Democracy* cannot intervene by force as without permission granted Him *by* the People, *of* the People, and *for* the people. Such is the spiritual symbolism of the *Sacred Verses of the Revolution*, in that it grants the *Spiritual Powers That Be*, express permission and authority to liberate the Peoples of Niger Area from the Satanical *Captivity of Niggahood* in Nigeria, onto the Transcendental *Liberty of Nationhood* in Nations of *New Age* Africa such as the *Arewa* Republic, the *Biafra* Republic and the *Oduduwa* Republic.

The *Sacred Verses* symbolizes an intellectual Revolution in Nigeria. (Revolution must be intellectually oriented that it may heal an Existential Pathology whose satanical virulence derives origin in unintellectualism, characterizing in outright idiocy.) Revolution founded upon intellectualism thus alone basks in its *Regenerativism*, favoring Identity *Cultivation* and Character *Development*.

The elevated status of intellectualism in the Sacred Verses is totally symbolic of intellectualism as *latent and resident* among African Nativities of the Niger Area. Thus what we have as a "nation" is nothing but an expression of political idiocy wreaking its satanic suppressionism, being as well a military imbecility wreaking its demonic oppressionism upon African Nativities so intellectually endowed. What an existential contradiction!

I am confident that *Prophecy of Democracy* is a true reflection of the thinking of the *Common Man* in the Niger Area. (In Volume 2.2.6.d and Volume 2.Summary.7-8, the Sacred Verses intimates us with the spiritual profile of the *Common Man*. He is *not* your underling!) If one could peep deep down into his heart, they would see the *Poetic Fantasy* therein. All I have done in the form of this iconic Poetic Fantasy is externalize the deepest thoughts and feelings of these African Peoples concerning "Nigeria".

For its radical spirituality and aggressive intellectualism, the *Sacred Verses* is symbolic of the fact that the *New Age* vision for *Creative Dissolution* of the Colonial Relic, as well as its *Constructive Liquidation*, is not a *street clamor*. It is an erudite-poetic vision of the African existence and experience. Thus critics of the Sacred Verses may be nothing but *"Nigerianists"* with nigga-psychopathical complexes of rulership over other Nigerians as a demonical function of the *Colonial* Mentality.

A book of this stature has not been written with the Nigeria Existence as subject up until the present era. It is totally iconic for the *Light* that if formally sheds on the African Struggle, which is a human struggle. It is symbolic of intellectualism and spirituality once latent, but presently totally manifest among African Nativities of the Niger Area. This elevated spiritual and intellectual culturing will sooner or later permeate the political scene, to actualize the miracle of *Revolution* as in the Holy Prophecy.

The *Sacred Verses* is symbolic of revelation of spiritual and intellectual culturing as of *New Age* Africa. I would challenge every celebrity among the enlightened elite in Niger Area to read the *Sacred Verses* in order to imbibe the *Divine Psychology* which must *enverve* as well as *ennerve* construction of the requisite governance psychology for *Cultivation* of the African Identity-Existence and *Development* of the African Character-Experience. Thus the divine mission of the emergent Leadership of the *New Age* would be bringing about the Revolution from Satanical *Niggahood* in the African Character-Experience, in Evolution onto Transcendental *Nationhood* in the African Identity-Existence.

Richard Igiri

b. I Am A Marketer!

To survive in Niger Area, everyone is selling one thing or another. Some sell cars, others sell textiles. For some it's machinery while for others yet electronics is it. Some will also be found selling clothing items, livestock, construction materials, *et cetera*.

While some sell wares, others sell services and yet a few, ideology. Whether they be wares, services or ideology, the marketplace accommodates the one as much as the other. What I am selling may seem weird, but the adaptability of the marketplace supports it in the category of "ideology".

So, proudly stated, I am selling the divine ideology of (*Self* Discovery of the African Identity as onto) Indigenous *Nations of New Age Africa!*

In the marketplace, those selling *Legal* Make pharmaceuticals and drugs are inclined to campaign against Lethal *Fake* products. This way they not only promote their own Legal Make products and increase sales, but also generally achieve a certain spiritual gratification in the knowledge that their Legal Make products saved lives and preserved dignity in society, as against Lethal Fake products which only wreak desecration of the life of humanity as well as negation of dignity in society.

Therefore do not blame me when I rail against *Lethal Fake* non-ideology of the *Colonial* Era, to promote my own *Legal Make* super-ideology of the Millennial *New World Order!*

Do not blame me for being a humble marketer! Do not hate me just because I am trying to sell my goods like everyone else sells theirs! I am only doing my job as a humble marketer, using totally legitimate techniques as is generally standard practice in the marketplace!

In the marketplace, my ad-campaign would go something like this: "*Do not* buy the *Old* Colonial Country! *Do* buy the *New Age* Nations! The *Old* Country is *toxic!* It is a (bad) product of Feudal

Aspect of Revolution in Nigeria

Intimidationism and Genocidal *Impositionism!* It only leads to *Perdition* in the Satanical *Captivity of Niggahood!* But the *New* Nations are *elixiric!* They are products of Spiritual *SelfIdeationism* and Cultural *SelfCreationism!* They lead to *Bliss* in the Transcendental *Liberty of Nationhood!*

"Therefore flee the Evil *Toxin* of the *Old Disorder,* which is fraudulently seeking to "rebrand" a *Bad Product,* than empty-away outright the evil contents of this pitch-black *Black Bottle!*

"*Nigeria* is nothing but the *rags* of *Slavery* and *Colonialism!* As a *Nigerian,* you are dressed in *rags* compared to the greatness that *Supreme Being* in His Infinite Love and Wisdom saw it fit to divinely deposit *inside* of you! You can be indefinitely *more* and infinitely *greater* than "Nigeria"! Remove those *rags* of a "discovered" Slave and I am this day offering you *real* custom-made beautiful *clothes* to define and adorn your true – gentlemanly and ladylike – full-human aspect of *Self Discovery* and *Self Mastery!*

"Do not bequeath this *Evil Toxin* to the children! You would be doing them and their generation of Mankind a great disservice! They will be languished in the Nonbeing of Satanical *Niggahood,* and their lips will be full of curses upon you! Rather embrace the *New Age* Nations and bequeath these to the children that they may revel in the *Life* of Transcendental *Nationhood,* speaking blessings onto you!"

So *exactly* what am I selling?

I am selling "*Self Discovery* of the African Identity in its Spiritual *Purity* and Cultural *Originality*" being as of incorruptible-pristine Indigenous Nations of *New Age* Africa! Plus ... I am *definitely* yelling at *"European 'Discovery'* of the African Character into Ideological *Artificiality* and Cultural *Superficiality"* being as of the corruptailing *Colonial Relic!*

So don't get it twisted! I am only a marketer, doing my job like everyone else! I am proudly selling the *Realism* and *Truth* of

Civil*Liberty* in Transcendental *Nationhood*, while yelling at the *Pseudism* and *Falsehood* of Evil*Captivity* in Satanical *Niggahood!*

c. Referendum in Nigeria

The *New Age* psychology as in the Holy Prophecy inclines that the ongoing Democratization process necessitates that Nigeria must be put to the test as to ascertain the real *value* of its *Unity, Sovereignty* – and *Nationhood* as a matter of fact – in the light of spiritual and cultural precedents of the *New Age* of *Self Discovery of the African Identity*.

Such a divine inquest of Democracy would seek answers to: *Why* does Nigeria exist? *How* did Nigeria begin to exist? *Should* Nigeria continue to exist in that same form against values of *Self* Discovery and Transcendental *Nationhood?* If not, then *what* should exist in its evil stead?

In an existential scenario of Transcendental *Nationhood*, in which *Democracy* operates totally unadulterated and pristine, the Unity of a Nation is not politically determined in *Impositionist* Feudal*Error* and its Civil*Sin;* nor is Sovereignty militarily defined by *Intimidationist* Genocidal*Terror* and its Evil*Savagery*.

A *country* like Nigeria being historically determined in *Impositionist* Political*Error*, and thus characteristically defined by *Intimidationist* Military*Terror*, could use a *referendum* for ascertainment of the popularity of its *Unity* as well as validity of its *Sovereignty* as a Nation among its Captive Nativities, being as against the operative value-system of this *New World Order* of *Democracy*.

As a country laying claim to *Nationhood* and *Democracy*, Canada passed such a test in a referendum of 1985, by which Independence for Quebec was defeated by the popular choice of the People. In the case of Sudan, a referendum as a process of the objectivism and transparence of *Democracy* proved that *Southern Sudan* was a psychological and cultural reality among its People, which mandated its Independence as a political entity.

As history shows, the Unity of Nigeria was politically determined in *Impositionist* Feudal Fraudulence, and its Sovereignty militarily defined by *Intimidationist* Genocidal Violence. And thus, as with Canada and Sudan, once put to the test in a referendum to determine its credibility and define its validity as a *Nation* in a New Age of *Democracy, can* Nigeria scale such a test by its own merit and credibility as of *Democracy,* or will it collapse to the true Spiritual *Aspiration* of its *Captive* Nativities for its displacement and replacement by *Indigenous* Nations of *New Age* Africa (as founded upon sacred principles of *Self* Discovery of the African Identity)?

The Divine Psychology of *New Age* Africa (being that of *Self* Discovery of the African Identity in Spiritual *Purity,* as well as of the African Character in Cultural *Originality,)* inclines to a *referendum* in Nigeria such as Canada survived to prove its mettle of *Nationhood* and Democracy, while Sudan failed the same test leading to Independence for *Southern Sudan.*

In the existential context of Sacrosanct *Democracy* and its spiritual and cultural precedents of the *New World Order,* the status of pristine *Nationhood* is *re*validated alone upon the sovereign authority of such a *referendum.* Alone thus re-constitutes the status of *Nationhood* as absolved from the ideological *Artificiality* of a *Feudal* Unity determined in *Impositionist* Political*Error,* as well as the cultural *Superficiality* of a *Genocidal* Sovereignty defined by *Intimidationist* Military*Terror.*

d. The Revolutionary and the Agitator

There is a huge wall of difference between the *Revolutionary* and the *Agitator.* A salient point of this dissimilarity is that the Revolutionary is a *transcendentalist*, motivated by concerns and forces *beyond* materialism. The Agitator on the other hand is a *secularist*, nursing complexes of being victimized by the dysfunctional system. He is just a "complainer" who is easily solicited and bought over. That easily and quickly his agitations can be doused, with his person cajoled into abandoning his petty complaints and "social critiques" for a piece of chicken (called "settlement" in *Nigerianism*).

With consciousness conditioned and bogged down in value-systems of the dysfunctional Old Order, the *Agitator* is typically "agitated" and angry. Feeling cheated by the nigga-establishment, he agitates for improved conditions within the established-dysfunctional Old Order. His agitations follow the pattern "If I can't have it, no one else should." And once he's given the power, he perpetuates the exact same Civil *Error* that peeves him – only perpetrated more sadistically. Psychologically, he is a part-and-parcel of the dysfunctional nigga-establishment he "criticizes".

But the *Revolutionary* totally self-etches himself *off* of the nigga-establishment he condemns as unGodly. Unlike the Agitator, the Revolutionary has a *clear-cut* Ideology by which he *Indemns* for what he *Condemns*. These characters are as far-apart from each other as *Day* is from *Night*, and *Light* from *Dark:* as Transcendental *Science* is from Satanical *Nescience!*

The *Revolutionary* takes suffering as a necessary part of *Life* that exposes *Identity* to conditions necessary for *Cultivation*, and thus equally exposes *Character* to processes necessary for *Development*. The *Agitator* on the other hand points the accusing fingers of his infantility at the niggaestablishment as the source of human suffering. He presents himself in his agitation thus, as the Chosen One who could have made things better to avoid so much human suffering that Mankind may live happily ever after.

The *Revolutionary* basks in contentment and is spiritually ecstatic as a function of elevation of consciousness above "value-systems" of the nigga-dysfunctional *Old* Disorder. He takes the spiritual onus to carve out a Path of self-reliance onto a functional *New* Order. The elevation status of his consciousness survived him through the jungle of thistles and thorns, and yet through the desert of scorpions and serpents. He thus carves out a *New* Path and bequeaths a spiritual legacy of self-reliance to his compatriots and their succeeding generations.

The Nigerian who frowns at the criminally-founded "salaries" his Dishonorable Legislooters receive, needs to do some soul-searching:

Aspect of Revolution in Nigeria

If he was the one receiving four or five times more dollars for doing nothing, against four-hundred thousand dollars that President of the United States receives, would he be complaining? The typical *Nigerian* would not! Here lies the difference between the *Agitator* and the *Revolutionary*: the former only *envies* the Dishonorable Legislooter, wishing indeed it was him holding such loot-dollar exalted-office; while the latter is only genuinely concerned that such distortion in proportions bodes the massive cataclysmic collapse of a "nation" whose very "sovereignty" has not been totally validated on an existential premise loftier than *Social Spoilage* and *Economical Pillage*.

A classic example of a *Revolutionary* is *Nelson Mandela* of South Africa. The apartheid system was an Evil he stood against, and the possibility of receiving "settlement" from this very same Evil to abandon the struggle against it, was non-existent. Another example is the Biblical legend *Moses,* who was under transcendental influence to lead Israel up and out of the Bondage of Egypt. These classic paradigms reflect that the *Reactionary* had no such wealth that could douse the resolve of the *Revolutionary* to achieve Civil *Liberty* for himself and his People.

The *Revolutionary* and the *Agitator* both reside in each individual: the one is only expelled to accommodate the other. The psychological focus of *New Age* Africa would inspire the individual for aspiration to be the *Revolutionary* of the spiritual ilk of Nelson Mandela and Biblical Moses. Mention must not elude us of the Pilgrim Fathers, who walked out on the wickedness and sorcery of *Old* Europe to found the Greatest Nation on Earth.

So, don't *ever* get it twisted! The spiritual *Aspiration* to *Self* Discovery of the African Identity remains unrelated to a secularist's self-motivated *Agitation* for "settlement" and position in the niggapetrodollar materialism of the nigga-establishment! The divine process of constitution of Spiritual *Purity* as of the African Identity and institution of Cultural *Originality* as of the African Character pursues the truly classic *Revolution* of the transcendentalist as divinely-motivated for a radical and

total departure from Satanical *Niggahood* onto Transcendental *Nationhood!* Even as Mandela, Moses or the Pilgrim Fathers, the Revolutionary of *New Age* Africa would seek no defilement with the *King's Meat* in the very same niggaestablishment which he must condemn in no ambiguous terms as satanic in origin and demonic in character.

e. The CNN Freedom Project

Analyzing the true nature of *Nigeria* as against the spiritual and ideological focus of *New Age* Africa, let us consider these questions as parallels: "What is *Slavery?*", and "What is *Nigeria?*"

In its Freedom Project, CNN has crafted this definition: "Slavery occurs when one person completely controls another person, *using violence* or the *threat of violence* to *maintain* that control, exploits them economically, *pays them nothing* and they *cannot walk away.*"

This CNN-Freedom-Project definition of *Slavery* paraphrases in *New Age* Revolution psychology thus: "*Nigeria* is a *Slavery* Institution which completely controls the African Native *using violence* and the *threat of violence* to *maintain* that control, exploits him economically, *pays him nothing* and he *cannot walk away.*"

The operative components of this *New Age* psychology definition of *Nigeria* as a (parallel of *Slavery*) condition of the African Native languished in *Slavery,* are as follows:

a) *Control:* The *Nigerian* did not create *Nigeria*, and so remains strictly *under the control* of those psychic forces of extrincism-malignity that *fabricated* Nigeria and *foisted* it upon him (as in *Intimidationism* and *Impositionism*). This *Control* Factor was and remains totally cancerous toward his wellbeing and welfare.

b) *Violence and the threat of violence* are employed politically and deployed militarily to hold that control sacrosanct. Nigerians, who would argue against *Dissolution and Liquidation* of Nigeria

Aspect of Revolution in Nigeria

as a political and military entity, remain mentally *cowered* and psychologically *cowed* thus, not that they would not absolutely love and be totally thrilled by a transcendental scenario in which that divine option actualizes. Rather being that Nigeria exists by *violence* and maintains its existence by the *threat of violence*, such Nigerians still *live in fear* (as in the psychological and social conditioning) of that aura of *terror* and *evil* from Nigeria's racist-imperialist, and ethnicist-militarist "foundation". But once violence and the threat of violence are removed (which is what *Democracy* should aspire to furnish the *Nigerian* with) it would become totally apparent that this divine option is in fact the most priced desire that he secretly nurses in the most reserved and sacred recess of his consciousness.

c) Perhaps no social index tells it more graphically than the press-anecdote this typical Nigerian morning, of the ailing-old pensioner who slumped and died right on the queue to be paid the *one thousand naira* (approximately *six dollars*) he is being owed by a shooter-looter *Slavery Institution*.

Beyond all fraud and manipulation, Nigeria is 100 years old (and not as would be the case when fraudulently calculated from the 1960 "Independence"). During this pathetic *century* of its pathological existence, it has consistently *robbed* the Nigerians, and typically *"pays them nothing"* – as in the case of the old-ailed pensioner who slumped and died on the queue for his pension.

d) Nigerians *"cannot walk away"*. The *Nigerian* is – spiritually, ideologically, and thus socially – a prisoner in a *facility* in which he is violence-guarded within towered restraint-walls capped with electrified barbed-wire. No physical means of escape exists within his diminutionism and emasculationism. It cannot be over-stressed that the "Nigerian" hoards complexes of being *held down* as the "Nigerian" *against his wish*. Yet no one can simply get up and *walk away:* but the *Nigerian* would do exactly just-that, if he only could. This leaves us with the spiritual approach, which offers the possibility of escape by Divine Rescue only.

f. A Dream of Technology

The Divine Psychology of the *New Age* African existence and experience negates "ethnic nationalism" as the expression goes. The Revolutionary mental focus of the *New Age* thus must reject that philosophy wherever it exists, which would suggest that Nigerians are so ethnically divergent they cannot get along simply on unholy grounds of ethnic differences. Ethnic divergence among Peoples of the Niger Area once harnessed creatively could constitute strength than weakness onto pristine *Nationhood*.

The divine process of *Self* Discovery of the African Identity in Spiritual *Purity* and the African Character in Cultural *Originality* would rather subscribe to Creative *Dissolution* of Nigeria just as another ordinary, common and familiar "*state-creation* exercise", which Nigerians are all familiar with and have *benefited* from. The novelty of this divine option lies in that it would be more dimensional with a more decisive developmental impact and benefit for the entire region and its Peoples.

My home town benefited from it when Abia State was created out of old Imo State – with *development* as the objective, which became relatively *accelerated*. Thus creation of three powerful *Nations* out of one weak and putrescent *Country* would go a long way in the noble *direction* of bringing *accelerated development* to the *African person and his environment*.

The Governments of the *New Age* Nations to emerge will be more compact, more efficient by virtue of being politically *less contradiction-ridden* and militarily *less conflict-driven* than satanically constitute the niggapetrodollar pride of Nigeria. The *New Age* Governments will boast dearer synergy with the *grassroots* Nativities for *Cultivation* of the African human person as well as *Development* of his native homelands. This holy arrangement would serve much better than does a so-called "Federal" *Nigga-rhetoric*, to whose alien and outlandish existence no *Nigerianist* has been able as a matter of fact, to ascribe a proper definition, which favors a *creative* significance and a *developmental* objective.

This Revolutionary mental focus of the *New Age* is one which likens *Leadership* in Africa to the small elite group who could think far ahead of the establishment in the tragedy of *Poseidon,* which helped them to "move upwards to the bottom" of the cruise liner in its keeled-over position. This small elite group escaped into safety before *Poseidon* took the final dive for its permanent abode at the bottom of the ocean.

It is not expected that those comfortable in the *niggaestablishment* will applaud such a mental focus of the *New Age* among the *Indigenous* Peoples of Niger Area. Just as the intellectual in *Poseidon* argued that "These things are not built to float upside down", such scientific "expert views" based on the *Indigenous* world view cannot be palatable to those who may be *Shooting* Nigerians in the name of its *Feudal* Unity, and *Looting* Nigeria for its *Genocidal* Sovereignty.

This mental focus of the *New Age* is *elitist* and *deliberately* placed in the unapproachable as relative to those psychologically warped and sadistic critics burdened with a run-down negative mind-set on issues of distressed human existence such as constitutes *Nigeria*. Certain of the comments one would come across once in a while in critique of Indigenous Nations of *New Age* Africa are representative of animal levels of consciousness, and unworthy of notice.

The leaned-forward mentation of the *New Age* pursues *Self Discovery* of the African Identity in its Spiritual *Purity* and Cultural *Originality.* Thus if there ever was talk or "prophecy" about a *cataclysmic collapse* of Nigeria, such a Divine Psychology of *New Age* Africa determines to be disassociated with, as well as distanced from it. The *Sacred Verses of the Revolution* as espoused in this divine mentation is very highly structured, making it impossible that ambiguity of any degenerative kind could lurk within those *Sacred Verses.*

The deliberate words that occur in the *Sacred Verses of the Revolution* regarding the *break-up* of Nigeria for the emergence of pristine Nations of *New Age* Africa as upon *Purity of Identity* and *Originality of Character*, are very explicit: *"Peaceable Creative Dissolution"* and *"Civilized Constructive Liquidation".* No literate person would

mis-read these Sacred Verses for "Cataclysmic Collapse". These extremes do not represent coinciding values of existence and experience. The one is *Regenerative*, meaning it would be for *Good* and accelerating *Cultivationism* and *Developmentalism*. The other is *Degenerative*, meaning it is for *Evil* and decelerating further into *Undercultivationism* and *Underdevelopmentalism*.

Advocacy-phraseology from the *Sacred Verses of the Revolution* represents superior mentation-comportment as divinely issued with utmost mindfulness. Words are very significant in all of life's undertakings, more so in a project ponderous as *Revolution! Words* create a nation or empire, even as words also easily destroy nations and fell empires. This would explain that the vision of *New Age* Africa as occurrent in the Holy Prophecy expresses in carefully-sculpted verses such as "*Peaceable-Creative* Dissolution of Political Powerstructures of Civil *Error* inhibiting the African Sphere-of-Existence against *Cultivation* of the African Identity, as well as *Civilized-Constructive* Liquidation of Military Powerbases of Evil *Terror* inhabiting the African Theater-of-Experience against *Development* of the African Character".

Surely, these carefully-sculpted *Sacred Verses* cannot by any stretch of a morbid (and moribund) imagination be mistaken for, or ever be mixed up with "violent disintegration" and or "cataclysmic collapse". *Revolution* thus lies occurrent upon a mental state of advanced creativism as operative in the African Identity, which determines to be distanced from any such degenerative phraseology.

So, don't get it twisted! Divine *Revolution* seeks *not* a *Cataclysmic* Collapse of Nigeria, and remains disassociated with, as well as distanced from any such grim prospect. *Revolution* rather fundamentally inspires *Self Discovery of the African Identity* as in its Spiritual *Purity,* as radically conspires Cultural *Originality* of the *African Character* thus!

This divine mentation of *New Age* Africa thus pursues (borrowing phraseology from the *Sacred Verses*) "Peaceable *Creative* Dissolution of the Political Powerstructures of Civil *Error,* as well as Civilized

Aspect of Revolution in Nigeria

Constructive Liquidation of the Military Powerbases of Evil *Terror"*, which constitute Nigeria's *Feudal* Unity and institute its *Genocidal* Sovereignty. Thus favors emergence of three beautiful, powerful and great *New Age Nations* of *core* African *Nativity:* the *Arewa* Republic, the *Biafra* Republic and the *Oduduwa* Republic!

This *New Age* psychology of *Revolution* thus remains determined to be disassociated with, as well as distanced from the word "disintegration" in reference to Nigeria. Spiritual *Aspiration* of the African Identity as in the *Sacred Verses of the Revolution* rather inclines to *Reintegration* of Niger Area, being that Nigeria is already in a non-status on *disintegration* as it is presently nigga-situated. This means that the *Cultivationist* principles and *Developmentalist* characteristics of *Nationhood* are absent and inoperative in *Nigeria*, which likens it to *Poseidon* in its *disintegration* non-status while keeled-over and floating *upside down.*

After a long-hard look at the socioeconomical and politicomilitary nigga-configuration called *Nigeria*, a gentleman of about age twenty-five opined that there is no discernible *direction* in Nigeria. This gentleman isn't too far-off the reality of the Nigeria Existence. This would explain that "sharing the money" and *Legislooting* remain the loftiest sovereign schema of those who become government officials in Nigeria. This would of course exalt its satanic *niggapetrodollarism* to the highest meaning and direction defining the Nigeria Existence.

Mentation of *New Age* Africa as upon such an insightful observation conspires *Aspiration* to a revolutionary escape from the *Meaninglessness* of the Nigeria Existence and the *Directionlessness* of the Nigeria Experience. *Revolution* thus conspires living Truth against a backdrop of fraudulence and falsehood in which "citizens" are forced to conform to the wicked *Lie* of the nigga-establishment in the attempt to survive as Nigerians.

Divine *Revolution* thus pursues *Truth* in a *Dream of Technology* for the African Existence beyond any "potential" of the spiritual hollowness of such a blatantly satanic Niggapetrodollar *Fiefdom*.

All African existence and experience become much better structured toward *Meaning* and *Direction* in these *Indigenous Nations of New Age* Africa as revealed in the *Sacred Verses of the Revolution*. These *Holy Nations of the New Order* are of course the *Arewa* Republic, the *Biafra* Republic and the *Oduduwa* Republic, to become totally emergent upon Peaceable *Creative* Dissolution, and Civilized *Constructive* Liquidation, of the old-ailing, corrupt-putrescent *Colonial Relic*.

This Psychology of *New Age* Africa, or *New Age* Mentality (whatever we may choose to call it), which seeks manifestation of the *Destiny of Africa*, liberates the African Identity from the nigga-psychopathy of the *Colonial Mentality* and its horrible works of *Undercultivation* of the African Identity and *Underdevelopment* of the African Character – as manifest in its tragic effects of wreaked socio-cultural pathology.

Spiritual *Liberation* of the African Character from the animal posture of its Colonial "Discovery" thus constitutes empowerment of the African Identity in *Self* Discovery to divinely institute *Indigenous* Nations of *New Age* Africa such as the *Arewa* Republic, the *Biafra* Republic and the *Oduduwa* Republic!

Taking *Biafra* as a divine super-archetype of *Self Discovery of the African Identity,* history shows a definite character and direction of *Technology*, whose proximity to the Colonial Relic remains a blatant "access denied". The dream for escape from the *Old Colonial Experience* to the *New Spiritual Existence,* issues forth from the divine and legitimate desire for restoration of the "lost" Technologies of *Africa*, of which once "retrieved" benefit Identity *Cultivation* and Character *Development*.

These great Nations of *New Age* Africa to emerge are not the thoughts of the mind of mortal man. They are neither works of the hands of man – such as colonizers, rulers, dictators and mass-killers – which Nigeria is. We would be burdened with just another "African" country in each case were they products of the degenerate mortal consciousness – as Nigeria remains.

These Great Nations are rather the *Thoughts of the Mind of God*, to be brought to total *Actualization* in the African existence and experience, by the very *Hand of God!* The spiritual status and cultural stature of these Great Nations of *Indigenous* Africa is such that we should not depend on the intelligence or the ability of mortal man to bring them to total *Actualization*. Being thus the *Thoughts of the Mind of God*, only the *Power of the Hand of the Almighty* can bring them to total *Actualization* in the African existence and experience!

As a *Spiritual Thought* in the *Mind of God*, each of these *New Age* Nations of Africa can only come to total *Actualization* in existence and experience through *Spiritual Power* and *Natural Force* similar to the volcano, tsunami, lightening and torrential rain! The divine process of total *Actualization* of the African Identity in *Self Discovery* upon *Divine Fiat* will be so power-charged and directional that it will uproot and topple every evil in its path, reducing them to mere ashes on its blazing Path of Holiness!

Revolution pursues a spiritual dream of Technological freedom and glory, which would take us back to *Biafra*, and perhaps as far as ancient Oyo Empire, Ife, Benin, Nok, *et cetera*. These Nations of *New Age* Africa thus represent such a status of technological glory in the African sphere-of-existence and theater-of-experience, divinely wielded of more than requisite spiritual authority and force for *Self* Actualization in total existential supremacy over their Evil Antagonism. Non-values of experience configured in the *Degenerative*, which stand in Evil *Captivity* against Civil *Liberty* thus, will be obliterated in the transcendental blaze of *Self Discovery* of the African Identity, even as the natural force of a tornado, volcano or a tsunami levels-out everything on its path of sojourn!

Dwelling upon this one Biblical allegory, when the Holy One of Israel decided to part the Red Sea for the Children of Israel to cross on dry land from the *Evil* Captivity of Satanical *Niggahood* in Egypt, onto the *Civil* Liberty of Transcendental *Nationhood* in Israel, what could almighty Pharaoh do, except stand helplessly transfixed at the action of *Transcendental* Power dwarfing his mortal puniness?

Richard Igiri

The *First*Premise Biafra was great enough, but the *Second*Premise Biafra as in the Holy Prophecy is a totally far-out spiritual Dream of *New Age* Africa. The Second Premise *Biafra* will break forth with such piercing spiritual power and dazzling divine glory that nothing of mortal materialism belonging to the *Old* Disorder can dare stand in its Path of Holiness!

The existential fabric of these Indigenous Nations of *New Age* Africa is spun upon the Spiritual *Purity* of the African Identity, as well as upon the Cultural *Originality* of the African Character. Their Divine Emergence will be by great spiritual power and glory such that in its spiritual bankruptcy, the corrupt-ailing *Colonial Relic* will have no power or authority to stand against the spiritual volcano and cultural tsunami of such a divinely-impelled *Revolution!*

If the *First*Premise *Biafra* was a *Military*Ambition in the Evil*Antagonism* of the *Old* World Order, the *Second*Premise Biafra is a *Democracy*Aspiration in the Civil*Survivalism* of the *New* World Order.

Thus, the *Second*Premise *Biafra* is not a *Military*Ambition as of the *Contentionism* of the *Old* Order, but a *Democracy*Aspiration of the *Conciliationism* of the *New* Order.

The *Second*Premise *Biafra* is not a *Triangle*, but a *Cone*. It is not a *Circle* but a *Sphere*. It is also not a *Square* but a *Cube*. It is equally not a *Rising* Sun, but the *Radiant* Sun!

Volume 2.Summary.12 of the Sacred Verses titled *Points of Radical Departure* dwells upon the transcendental status of Identity-Existence in the Indigenous Nations of *New Age* Africa as distanced from the satanical non-status of Character-Experience in the morbid-moribund *Colonial Relic* of the Old Disorder.

1. Once upon a time, a gentleman and a young lady were caught up in a discourse on the divine-concept, *Biafra*. She was the beauty-and-brain type, about eighteen years of age and on the threshold of the University. She had apparently heard so much about *Biafra*. She felt for *Biafra*, but wanted to know more. She was skeptical but sincere, and needed to be sure that *Biafra* is not just another "African" revolution, which sooner or later brings the African Identity-&-Character right back to Square*One*, worse-off.

2. She wanted – needed – to be reassured that *Revolution of Biafra* would not turn out to be just another "African" illusion like "Independence". As *Biafrans,* she inquired, am I sure we would not be just another problematic (pathological!) existence only similar to that from which we would have been rescued?

3. After so much pains and we eventually do have our *Dream* for a *Sovereign State of Biafra*, how can I be so sure it would be worth it?

4. What's the big deal about *Biafra*, and what big difference would *Biafra* make for us as *Ibos* and *Ibibios*, *Calabars* and *Kalabaris*, *Ogonis* and *Andonis, et cetera?*

4b Thus what are the *points of radical departure* between our Cultural*Experience* in the Evil*Captivity* of the Satanical *Nescience-of-Niggahood* in Nigeria, and our Spiritual*Existence* in the Civil*Liberty* of the Transcendental *Science-of-Nationhood* in *Biafra?*

10 *Point Four:* Technologically speaking, *Biafra* divinely basks a millennial departure from the techno*pathy* of Nigeria. History credits astounding technological feats to *Biafra* in the region of *Orthodox*Technology. For example, the rocket they were developing in its embryonic stage at the time was already covering up to seven miles.

10b Yet the divine-concept *Biafra* also features the *Unorthodox*Technology, such that the possibility exists for a type of car for example, with bodywork of wood, aluminum or even fiberglass. This *noumenal* car configured upon the *Noumenal* Energy can float two feet off the ground and *fly* at terrific speeds! This "genre" of super-dimensional cars operates uncumbered by the Laws of *Phenomenon,* being built on the Law of *Noumenon.* (A scene in the movie *Star Wars* shows the queer four, Kenobi, Skywalker, R2D2 and C3PO cruising in such a *supercar.*)

11 This technology existed in the "lost" continents, but nothing is ever totally *lost* in the Cosmic Universe. Since we are simply recycled Humanity from those lost civilizations, it is possible to "retrieve data" from these civilizations as required, by furtherance of consciousness. This involves renunciation of warfare. The Second Premise *Biafra* as revealed in the Sacred Verses of the Revolution, pursues such advanced spiritual consciousness and its latent technological possibilities.

12 *Point Five: Nigeria* is a product of race-hate as harbored by *Imperial*Europe for *Indigenous*Africa.

13 Thus "discovered" through *Hate* came the *Unwanted*Baby that no one truly ever Loves – not *Mama*Africa, and certainly nor *Papa*Europe. If the *Colonial*European invented *Nigeria* as an expression of *Hate* for his African*Slaves*, what stops the African himself taking the divine onus in a bold step of *Self*Discovery, as for expression of *Love* for himself onto *Self*Mastery over his uniquely African circumstances of existence – as in the *Holy*Nation, *Biafra?*

14 *Point Six:* The *Unwanted*Baby as a product of *Hate* from the *Foreign*Bitterheart has a certain type of African*Character*, while the *Loved*Baby as a product of *Love* from the *Home*Sweetheart has a certain type of African*Identity*. The *Unwanted*Child came only for to Steal, Kill and Destroy, while the *Beloved*Son came that we may have *Life* and have it more abundantly.

Appendix
WE NEED LOVE IN NIGER AREA!

a. Preface to Appendix: Wallower in Futility and Failure!

It was only human that the Colonial Master hated his "discovered" African slave-subjects: They did not look like him. Further, they had "contributed nothing" to *his* Civilization – except of course *Slavery*. Thus *Hate* is a significant component of the "discovery" process – and in fact a pivotal constituent of the foundation philosophy – of *Nigeria*.

If the Colonial Master hated his black "discovered" slave-subjects, it is understandable: they were very alien to his nature and culture. That was in the World Era of *Slavery* and *Colonialism*. The big question of the *New Age* however is: Should the African himself continue to exist in the psychological conditioning and social structuring that were brutally foisted upon him in an obsolescent World Era in which misunderstanding and *Hate* dictated relations between Peoples of the Earth?

The *Nigerianist* is the pathetic creature born in Misunderstanding and bred in Hate. During *Slavery* he only vegetated existentially, and thus was captured and enslaved: he contributed *Slavery* to World Civilization! Then came *Colonialism*: he relegated culturally just to be "discovered" into Nigerianism. Yet in this *New Age* which affords opportunities ample for self-recognition, he continues to vegetate-and-relegate in the fetters of a bygone World Era (Nigeria) – determined to remain on the Negative Side of every World Era that comes along! Thus whichever World Epoch is in place, he typically makes his comfort zone at the *Grand Bottom* – the vegetating *scum of the earth!*

There is no dignity however – and certainly no honor either (neither is there any *Independence* and *Civil Liberty* of the holistic kind) – in being the "discovered" *scum of the earth!* No one should be so self-satisfied in the complacent Niggahood-pride of a *wallower in futility and failure!*

The Message of the *New Age* to the African Identity as in the Holy Prophecy is simple: "You must *invent* yourself to upgrade to spiritual standards and update to cultural trends of the *New Age!* If you do not achieve Self-invention, you will continue to be "discovered" and invented by forces of historical negativism outside of your *Self*-survivalism. You won't look good! The Age of *Slavery* and *Colonialism* hated and fettered you, giving you no means for Self-recognition and Self-actualization. Wallowed in the fetters and thus swallowed in the tatters of *Hate* as of the Old World era, you invented *nothing* for your *Self* and contributed nothing to the World!

"However, this New Age of *Individualism* and *Technology* – with its Democracy as World Civilization – is one in which it is possible to at least *Love* yourself! What do you plan to *invent* by loving yourself when you were hated and brutalized with *Slavery* and *Colonialism* by the Ruling Powers of the Darkness of the Old World Era? If you cannot invent anything, you can at least invent yourself – as in *Self Discovery* of the African Identity in Spiritual *Purity* and Cultural *Originality* onto *Indigenous Nations of New Age Africa!*

"You cannot remain the 'discovered' *Effect* of negative World trends! You must tune-in and log-on to being the dignified *Self*-Discovered *Cause* of positive World trends for a change!

"*Love* is the MasterKey that opens and enlivens the *Imagination* onto *causality and creativity* as in *Indigenous Nations of New Age Africa!*"

b. Appendix: We Need Love in Niger Area!

There is an abundance of everything in *Niger-Area*. Well, *almost* everything!

To begin with, Niger-Area boasts total-abundance of its nigga-petrodollars – typically flowing like milk and honey!

Supporting the super-abundance of its nigga-petrodollars, Niger-Area prides in its Cabals and Cliques, pedophile(?) senators and legislooter(?) lawmakers, public-hater law-enforcement agents and grassroots-distanced "representatives". The list is interminable.

Thus while Niger-Area boasts these manifestations of its nigga-sophistication, the divine energy called *Love* has found no honor and glory in its *Nigerianism*.

And what is *Love*, we may ponder at this juncture? Why the emphasis on this *Divine Essence,* which lies dignified in its total-estrangement to *Nigerianism?*

Well, simply stated, *Love* is the *Supreme Creative Energy* of the Universe! Without this Creative Principle in total-operation, no *People-of-the-Earth* can expect accession to the status of a *Nation-of-the-World,* let alone flourish thereupon.

Love is that all-important and all-inclusive *Creative Principle* that all *Peoples-of-the-Earth* must learn to "control" and apply thus for self-actualization into the ranks of *Nations-of-the-World*.

The firmament and constellations – even Mother Earth Herself and Her Children – are products of *Love!*

It is not possible to create *New Life* without consciously wielding this Creative Principle, *Love*. But everyone wise enough admits that *Creation of New Life* is totally due in Niger-Area. This makes it all the more imperative that we learn the workings of this *Supreme Creative Energy*. This empowers the People to create *New Life* in

Niger-Area in extrication from the *Old Dearth* whose degeneracy continues daily to violate the dignity of the human person while negating the sanctity of life.

In the culturing process to achieve mastery of this *Supreme Creative Principle* and its application, let us consider the *North-South* rift in Niger-Area.

Whoever said that *Love* cannot be found and founded between the *South* and *North* of Niger-Area?

In all truth, *Love* is already there and everywhere present. The *technology of attitudes* is all that is required by which to "extract" that *Supreme Creative Energy* to be applied in definition of the true *Nationhood* status.

Consider the divine symbiosis between *zobo* and *suya*.

A gentleman from the *South* meets a beautiful girl from the *North*. He has a passion for *zobo*. She is totally adept at making *zobo*, having acquired the *skill* and inherited the *technology* from her Northern ancestry.

He takes her number immediately, establishing the divine *Love* with the North, which furnishes him with uninterrupted supply of sweet *zobo* from his Northern girlfriend.

Also, a beautiful girl from the *South* has a passion for *suya*. She meets a Northern gentleman with cultured *skill* and updated *technology* to produce and keep her uninterruptedly supplied with sweet *suya* from the North. Meanwhile, the gentleman from Aba in the South has arduously cultured shoemaking skills and evolved the relevant technology. Right before the very eyes of his Northern brother from Kano, he crafts exotic shoes for him with his bare hands.

The lovely lady from Uyo in the South is empowered with relevant technologies. She would have cultured the skills of a professional

seamstress, and thus crafts beautiful dresses for her Northern sister right under her very nose.

What a beautiful divine-scenario of *Love* and interdependence!

This divine-scenario of impeccable *Divine Love* between the North and South once actualized, it becomes easy to advance to the next level in the process of definition and actualization of the *Nationhood* status.

Now *Individualism* is the creativism of *Love* in expression. *Individuation* thus could be defined as a situation in which a personality or ethnicity achieves "specialization" for its spiritual latency and cultural potency in the process of emergence onto *Nationhood*. It is apotheosization from Infancy and Childishness to Adulthood and Maturity – through *Love*.

In Volume 2.1.1, the *Sacred Verses of the Revolution* puts it thus in the following verses

> 30 An infant all too soon no longer an infant faces the reality of having to acculturate the uniqueness and fashionability of *Individualism*. At adolescence or adulthood proper, the infant garments once chosen for it by the Guardianship (*Nigerianism*), quite naturally cannot continue to be fashion, being as totally out-grown, ...
>
> 31 Once an infant under Guardianship, yet presently emergent onto Adulthood having to face the adult responsibility of self-determination, the human personality thus must turn versed in the art to *SelfIdeate* spiritually, as well as *SelfCreate* culturally, being as upon the hallowed *New*Ground of *Individualism*.

> 33 The infants' garments now vastly out-grown, their fabric and print an embarrassing oddity in the esthetics of the contemporary order, Identity-&-Character alone thus, being as totally emergent onto *Individualism*, may choose the pattern of *Regeneration* appropriate for emergence onto relevance in the cultural realities of the *New*Ground it must learn to tread.

Consider the *humanity* of an African family scenario with one father and three mothers of three brothers. *Tension and contention* soon surfacing is an index of family growth among the Brothers. They cannot grow without it, and their challenges with one another should be taken in a positive light as a necessary manifestation of the growth process.

In Volume 2.1.6, the *Holy Scriptures of the Revolution* says in verses 19-20

> 19 In the *Nigeria*Existence lies a pattern of *crowding* by which, figuratively speaking, full-adult members of a family inclined to different lines of personality-orientation live together. They so live together not in the Civil*Liberty* of a stately family mansion, but in the Evil*Captivity* of a dilapidated, dejected, crammed lone-room rented apartment. Noteworthy also lies that they do not so "live together" by an act of the Frugal*Choice* of Civil*Excellence*, but are only so yoked-up by the Brutal*Chance* of Evil*Violence*.
>
> 19b In this kind of crowding, a personality-type may wish to study during a certain hour of the day, and the other sees the occasion fit only for loud revelry. The *Nigeria*Existence remains this pattern of the Niggahood*Chaos*, than could ever "develop" into Nationhood*Cosmos* of any kind. The incompatibility of their pursued desire-patterns as well as the irreconcilability of their personality-rearings in this *Durance-of-Niggahood*, can only get worse as they get older and facilities once in mere obsolescence, degenerate further into Total*Collapse*.

20 The personality-types so held-hostage in this kind of a negative and unproductive family situation, could have lived together pretty well in their respective InfantInclination, but as full-adults and each having "branched-off" into their AdultOrientation, only naturally must take to their own independent-adult Walk of Life in their own families thus Individuated.

If the Three Brothers are stunting, they will remain comfortable in the oppressive and choky traditional family house into which they were "discovered". But once the need becomes urgent to *grow* and *develop* their latent endowments, they must *individuate:* they must move out and spread out to their respective *individuated* homes. What a hellish condition it would be if all Three Brothers got married and started to have children in the same old ramshackle one-room-apartment-styled traditional family house?

Break-up of the Brothers in this *constructive* and *regenerative* context establishes in grand-accord with the *Law of Life*: one which mandates *individuation* and progression as opposed to *asphyxiation* and stagnation.

Break-up of the Three Brothers in this *regenerative* context thus constitutes attainment of the existential status of *Love*. Divine empowerment is obtained thus for *New Life* to be created.

Break-up of the Three Brothers in this regenerative context does not mean that they are no longer of one and the same spirit: it simply means their oneness is redefined onto *maturity* favoring advancing creativity, which grants individuation against asphyxiation, progression into *Newness* instead of stagnation in *Obsolescence*.

The British permitted only one level of Independence: the *elementary* level. That this *Elementary-Level Independence* from Britain defines and grants Civil *Liberty* in the holistic context is a function of the *Colonial Mentality* and the Civil *Error* of its evil concomitance.

The *secondary* level of Independence – as of advancing *Nationhood* and holistic Civil *Liberty* – is achieved *within* the African culture as amongst the "discovered" Nativities. The *Secondary-Level Independence* thus would occur when the Three Brothers achieve independence *from each other.*

Neo-Independence is occurrent thus as dispels the Evil *Captivity* of the psychological conditioning and social structuring of being "discovered" from outside Africa in the existential context of *Slavery* and *Colonialism*. This divine status of *Self* Discovery grants Civil *Liberty* to pursue the holistic identity-cultivation and character-development.

The mission of the *Indigenous* Nations of *New Age* Africa to emerge is *spiritual and ethical cultivation* of the African Identity-Existence, as well as *cultural and esthetical development* of the African Character-Experience, being as onto pristine *Civil* Liberty.

The *Indigenous* Nations of *New Age* Africa to emerge thus would explore the *Tertiary-Level* Independence for the Three Brothers. Ideological focus for the Nations of *New Age* Africa would be "Cultivation of *Spiritual Ethics* in the African Identity and Development of *Cultural Esthetics* in the African Character", being equally as onto impeccable-imperturbable *Civil* Liberty.

www.ingramcontent.com/pod-product-compliance
Lightning Source LLC
Chambersburg PA
CBHW030759180526
45163CB00003B/1092